IMAGES
of America

FIREFIGHTING IN WASHINGTON, D.C.

D.C. fire horses Barney, Gene, and Tom pound down East Capitol Street pulling Engine 18 as the proverbial sparks fly in the ceremonial "last run of the horses" on June 15, 1925. Motorized apparatus had arrived. The steam engine today is in the collection of the Capitol Fire Museum and Association of Oldest Inhabitants. (CFM.)

IMAGES
of America

FIREFIGHTING IN
WASHINGTON, D.C.

The Capitol Fire Museum

ARCADIA

Published by Arcadia Publishing
Charleston SC, Chicago IL, Portsmouth NH, San Francisco CA

Printed in Great Britain

Library of Congress Catalog Card Number: 2004110483

For all general information contact Arcadia Publishing at:
Telephone 843-853-2070
Fax 843-853-0044
E-mail sales@arcadiapublishing.com
For customer service and orders:
Toll-Free 1-888-313-2665

Visit us on the internet at http://www.arcadiapublishing.com

KEY TO COURTESY LINES

JGC: Jackson Gerhart Collection
JB: James Embry Collection
LOC: Library of Congress
HSW: Historical Society of Washington
DCFEMSPIO: Public Affairs Office of the D.C. Fire/E.M.S. Department HABS: Historic American Building Survey
CFM: Capitol Fire Museum, Inc.

(*on the cover*) Fire department training encourages urban renewal. Taking a break are firemen from Engine 13, Engine 7, Truck 10, and Rescue Squad 1 after they burned a vacant building in Southwest. In the next decade, thousand of homes in old Southwest would be demolished. (JCG.)

CONTENTS

ACKNOWLEDGMENTS

This book is dedicated to the D.C. firefighters who hold history and tradition sacred to their hearts, and particularly to those brave men who, on a mission to retrieve important historical items that upper management labeled as junk, endured ridicule and overwhelming stench to root through dumpsters and trashcans. Their vision and intuition will persevere in the department, as will the photographs, company journals, and ephemera they salvaged.

We would also like to thank the greatest known D.C. firefighters, the men who saved the world during the Second World War, and then spent 20 or more years fighting fires in the nation's capital. The heyday of Washington firefighting was between the late 1920s to the mid-1970s; the volume and magnitude of those fires have not been matched by any others in the city's history. Many firefighters during that era also endured the constant fear of the Cold War, a fear that is comparable to today's threat of terrorism.

Finally, special thanks go out to Jim Embrey, who supplied knowledge and many photos, and to Jackson Gerhart, whose love of the D.C. Fire Department and its history has been an inspiration to the author for many years and a milestone in creation of this book. Special thanks also to retired deputy fire chief John Breen, whose admiration of the department's history led to his co-founding the Capitol Fire Museum; thanks to Sally Berk, renowned architectural historian, for her tireless efforts in preserving the future of historic D.C. firehouses, and for the countless hours she dedicated to researching their history. We are grateful to the board of directors of the Capitol Fire Museum and the Association of Oldest Inhabitants, whose devotion is guiding the development of a world-class fire museum in the city. Thanks to Phil Ogilvie, president of the Association of Oldest Inhabitants, which helped locate and store precious old fire apparatus until an appropriate museum is created; thanks to Rich Schaffer, who spent countless hours gathering and organizing the images, scanning them, and writing the captions and text. Most of all, a special thank you goes to the D.C. Firefighters Union Local 36. Firefighters in this city could have accomplished very little without the strength and unity created by the union, and all firefighters are indebted to it. Finally, we thank the men and women of the D.C. Fire Department, many of whom have endured the toughest times in the history of the department, but like those before them, gritted their teeth and survived. This book is for you.

The personal opinions of the author do not necessarily reflect the opinions of the Capital Fire Museum. *Firefighting in D.C.* is an original work by Rich Schaffer to benefit the Capitol Fire Museum, Inc. Proceeds from the sale of this book go to the Capitol Fire Museum.

INTRODUCTION

Firefighters across the globe share a common heritage; they have come from a long line of people who understood sacrifice and devotion, who risked their lives to save others. Today firefighters are reminded of this history every time the alarm rings and the engine leaves the firehouse; they are filled with the knowledge that through these doors have passed 200 years of firefighters.

In our nation's Capital, firefighters assume unique responsibilities. The Capitol building, the White House, and other government offices are some of many federal structures that require fire and emergency medical services from the D.C. Fire Department. Many buildings here are enormous, exempt from D.C. fire codes, and contain substantial fire loads but no sprinklers or alarms; one such example is the Martin Luther King Library. Also in need of protection are the thousands of homes, schools, stores, private buildings, parking garages, railroad terminals, and Metro stations that make up the city.

Adding to the mix the steady influx of government employees and tourists, fire department resources are often strained. When multiple emergency incidents take place at one time, it is sometimes hard to handle them all. But through the years, one tradition has held true: the D.C. firefighters can hold their own. Because in the early days the nearest fire department upon which to rely for help was 35 miles away in Baltimore, the D.C. department was organized so that it did not have to rely on mutual aid from other jurisdictions. Today, as surrounding jurisdictions and volunteer fire companies in the suburbs are as busy as the D.C. department, the firefighters there are grateful that the previous generations developed such a self-reliant, well-planned urban fire department. As the D.C. population grows, so will the fire department so central to the city's survival.

This book is not intended as a scholarly historical research project, but rather as an enjoyable collection of images, facts, and lore compiled to educate the public about firefighting in D.C.

One

A TRUER, NOBLER, TRUSTIER HEART

Washington's first firemen were from all walks of life. Between 1804 and the end of the Civil War, several fire companies were established and offered non-subscription services. Many soon divided, and some wards were unprotected for years. The first fire companies—the Union Fire Company, the Columbia Fire Company, and the Anacostia Fire Company—organized in 1804 to serve the White House, the Capitol, and Anacostia, respectively. The Alert Engine Company organized in 1814 at the Treasury Department. The Star Fire Company, organized in 1826 at Fourteenth Street and Pennsylvania Avenue NW, moved and reorganized as the Franklin Fire Company. The Perseverance Fire Company organized in 1836 at Eighth Street and Pennsylvania Avenue NW. In 1840, the Northern Liberty Fire Company organized at Eighth and K Streets NW. The Western Hose Company organized in 1854 at Twenty-third Street and L Street NW. The American Hook and Ladder Company and the Metropolitan Hook and Ladder Company organized in 1855; the former was housed on Eighth Street Northwest and the latter at 438 Massachusetts Avenue NW. (LOC.)

Vigilant Firehouse (DC-98), 1066 Wisconsin Avenue, Northwest. East elevation shows wings added in the late nineteenth century for commercial use. Built 1844. (HABS, 1964)

In Georgetown, the following fire companies were formed and disbanded: the Potomac Fire Company in 1813, the Vigilant Fire Company in 1817, the Mechanical Fire Company in 1819, the Eagle Fire Company in 1827, the Columbian Fire and Hose Company in 1827, the Western Star Hose Company in 1831, and the Potomac Hose Company in 1864. The quarters of the Vigilant Fire Company are pictured here. The firehouse opened August 10, 1844, and was their third house in as many decades. In 1867, the Vigilant was renamed Georgetown Fire Company 1 with the addition of a steam engine. Today it is privately owned. Much of the original building was lost in a mediocre attempt at restoration several years ago. A hand-carved marble plaque on the front of the building memorializes an old mascot: "BUSH, THE OLD FIRE DOG, DIED OF POISON July 5th 1869 R.I.P." (HABS.)

THE CITY OF WASHINGTON THE CAPITAL OF THE UNITED STATES OF AMERICA WAS TAKEN BY THE BRITISH FORCES UNDER MAJOR GEN'L ROSS

Lots of lore exists about the organization and activities of the early volunteer companies in Washington, but there are few facts documented. There is in-depth information, however, on Washington's largest conflagration, which occurred September 1, 1814, during the War of 1812. At least 20 fires were set within one hour, leading many to believe these were acts of spies, not British soldiers. This phenomenon helped establish the city's volunteer fire companies. (LOC.)

This was the first and last major conflagration in Washington—but not the last time the White House and Capitol burned. With much of the city in panic or evacuated, and nearly every man at arms, few firefighting tools other than bucket brigades were available. Fortuitously, severe thunderstorms and tornadic activity quenched the fires and drove out the British. The next day, when this image was put to paper, citizens ensured no more fires be set in the city. One of these watchmen, John Appold, was apprehended for setting a fire and was accused of being a British sympathizer. Before he was taken to jail, a mob hanged him from a tree. (LOC.)

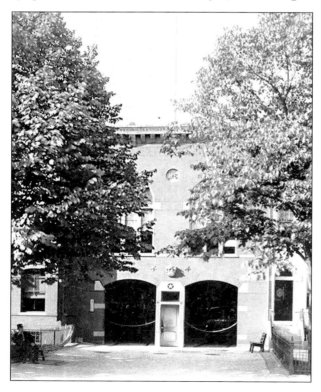

Washington's oldest extant firehouse, built in 1855, is the Metropolitan Hook and Ladder Company Number 1 Firehouse at 438 Massachusetts Avenue NW. This volunteer firehouse was built with double doors and two stories and was funded by private donations, dues, and municipal support. On the upper façade is a "No. 6" medallion, and below that is a concrete medallion, originally carved in wood, then cast in plaster, and then re-cast in concrete. Neither the original nor the mold still exists. The medallion depicts numerous hooks and poles, a crest, and the letters "MHL." Vandals have recently tried to remove it, causing damage to the structure and the medallion, as it is set approximately two feet into the façade and tied to the building's center with an iron rod set in the casting. It weighs more than 400 pounds. (JGC.)

"Subscription" fire companies never existed in Washington, as all were created with municipal or federal funds, membership dues, and fund-raisers. As such, buildings were marked to identify which fire-insurance company the owner subscribed. Volunteer companies often had an interest in the insurance companies: rewards were given by insurance companies to the fire companies as an incentive, so firefighters made an extra effort to salvage the contents in buildings with their insurance company's mark. The primary D.C. fire insurance companies were the Potomac and the Firemen's Insurance Companies; the mark of the latter is seen on this Federal period house in Georgetown on P Street NW. The quality construction of the *c.* 1820 house prevented conflagration in Washington. Today's firefighters' standard operating procedures were born out of fighting fire in such a structure. A brick party wall and slate roof prevented exposure problems. (Author's collection.)

On May 6, 1856, while the Columbia engine was going down Capitol Hill to a fire at Shreeves Stables on Seventh Street NW, fireman Benjamin Grenup stumbled, fell, and was run over by the engine. Six firemen stayed with Benjamin, who died an hour later. The suspicious fire caused substantial damage. Three days later, during the funeral, Shreeves's other stable was set on fire. The companies were delayed, and the fire grew to great proportions. After arriving, a fireman was trapped by a collapse. He survived but suffered serious injuries. Typical of the times, an obelisk was erected with this carved panel to memorialize Grenup's death. The epitaph reads, "A Truer, Nobler, Trustier Heart, More Loving or More Loyal Never Beat Within a Human Breast." (Author's collection.)

Rowdies and Rum

Grenup's death on a larger scale represents the end of the volunteer era in Washington. Many also blame the demise on the rowdies, firefighters who lacked professionalism in an emergency. Others argue that the advent of steam fire apparatus required the use of horses to pull it, thereby demanded 24-hour care for both steamer and horse. In September 1856, the city enacted several safety and operational bylaws that every volunteer company had to follow. These by-laws aimed to rid the rival companies of their rowdies and mischievous ways. By 1861, the first bill was introduced for creation of a paid department; the bill was defeated, overshadowed by the coming of the Civil War. Many volunteer firemen signed up for military service, thus reducing their ranks. The Martin Scorsese film, *The Gangs of New York,* well depicts the type of ruffian found in the fire companies. (John Morris.)

WILLARD'S HOTEL, WASHINGTON, SAVED BY THE NEW YORK FIRE ZOUAVES.—SKETCHED BY OUR SPECIAL ARTIST.—[SEE PAGE 331.]

At the outbreak of the Civil War, President Lincoln called for thousands of volunteers to defend the Union, particularly Washington, D.C. Troops arrived to receive orders or just stand by; one such troop was the New York Fire Zouaves, which consisted of former New York City volunteer firemen, under command of Col. Elmer E. Ellsworth. A major fire, pictured here, occurred at a liquor store next to the Willard Hotel, where many important dignitaries were staying. The Zouaves had arrived in Washington that day, and though exhausted, commenced to commandeering, with little resistance, the Washington volunteers' apparatus. After they extinguished the fire, their heroic acts were overdramatized in *Harpers Weekly*, which depicted the men's acrobatic skills to be as impressive as their firefighting. Colonel Ellsworth even went so far as to grab the speaking trumpet of a volunteer fire officer and tell him he had more men working, so he was in charge! (LOC.)

The Zouaves came to Washington for the war, but their instinct to fight fires won the hearts of many Washingtonians. This was the beginning of the end for the city's volunteers. After it was decided that federal firemen would protect the city, the Washington volunteers, deemed Southern sympathizers, were put out into the street with their belongings. This image of the Willard Hotel fire depicts a rare view of Washington volunteer fire company apparatus. While no ladder companies appear, three hand pumpers and one "crab" or hose reel is seen in the foreground. (LOC.)

City workers inspect hollowed logs unearthed along Pennsylvania Avenue c. 1950; the logs had been buried almost 100 years and had served as Washington's fire main system. Washington's fire main system, begun in 1853 by Montgomery Meigs, was one of the nation's first. Logs extended vertically out of the earth about three feet. A plug was wedged into an opening and fitted to accept an engine's hard sleeve, hence the name "fire plug." A technological marvel at the time, the logs held up well and were naturally insulated from freezing. Such logs are still found around the old boundaries of Washington today, and a collection of them exists in the Water and Sewer Authority (WASA) museum near the McMillan Reservoir. (HSW.)

Another catastrophic fire occurred on November 4, 1861, at the Washington Infirmary on E Street NW. An hour after the initial alarm, the first volunteer fire companies arrived to find many of the patients jumping from upper stories. Note the limited apparatus in the foreground. Fortunately, the metropolitan police had arrived on the scene just after the alarm and evacuated many patients. The influx of soldiers into Washington and the overcrowding of buildings doubled the number of alarms to which the fire companies had to respond; it became obvious that eight fire companies could not protect a population that doubled in one year. The structure was a total loss. (LOC.)

A catastrophic fire that occurred on December 26, 1861, was dubbed "Washington City's Cruelest Fire" by the *Washington Star*. The fire consumed Camp Fuller, a depot where as many as 30,000 army horses and mules were stabled. Several thousand horses stampeded into the streets, hampering and overwhelming fire companies; again, the buildings were a total loss. One can see here a single hand pumper and a gallant though hopeless effort by the Washington volunteers. More than 200 horses died in the fire, and many more were found throughout the city burned, injured, and wandering aimlessly until a humane soul dispatched them where they stood. Shortly thereafter, the army stables were moved to Gieseboro Point, today's Bolling Air Force Base. (Junior League of Washington.)

The Hibernia Fire Company of Philadelphia was one of the country's first to own a steam fire engine, which was taken during the war and, as part of a federal fire department, used to protect government property. First stationed in Fortress Monroe, Virginia, the engine came under fire by the Confederate ironclad, *Merrimac*. Shortly thereafter, through the givings of Congressman Thomas Florence, the Hibernia was made part of a federal fire department in Washington. Two other well-equipped steam engines were brought into service for this purpose, much to the quandary of the Washington volunteers. Frequent fistfights between the volunteers and federal firemen over who had charge of a burning building occurred, until an agreement between them stated that federal firemen would only be in charge of fires in federal buildings. Of course, nearly every building in the city was appropriated by the federal government for the war. (Insurance Company of North America.)

Philadelphia's Hibernia Steam Fire Engine, built by Reanie, Neafie & Company in 1859, was brought to Washington on September 15, 1862, as part of the United States Steam Fire Brigade, which commandeered the Union Fire Company's quarters at Nineteenth and H Streets NW and evicted the volunteers, despite much protest and resistance. (JCG.)

On November 23, 1862, an effort was made to reorganize the volunteer companies. John Peabody was elected chief engineer of all volunteer fire companies. Though a good idea, on May 19, 1864, it was decided that a paid department for Washington was in order. At the time, thin ranks of volunteers were found manning 10 fire companies: Union, Franklin, Vigilant, Perseverance, Columbia, Northern Liberty, Western Hose, Anacostia, and the Metropolitan and American Hook and Ladder Companies. Some 150 members were responsible for the city with an expanding wartime population. The city wallowed in humid summers and primitive sanitation and was in constant threat and fear of invasion. A military post in Washington was considered a hardship by many. Hundreds of private homes and buildings were condemned by the federal government for troop housing, and many Washingtonians moved to the suburbs. Fires, accidents, and illness occurred daily. (JCG.)

On October 12, 1864, the city received its first fire alarm telegraphs, known as the "Crystal System." Primitive and unreliable, they were mostly paid for and installed by the federal government. Twenty-five fire telegraph boxes throughout the city were activated by turning a crank. They rang a series of bells at the fire alarm headquarters, located at 482 Louisiana Avenue NW. This system remained in service until invention of the Gamewell system which, on September 30, 1875, included installation of 50 more telegraphs. Here is one of the earliest Gamewell fire alarm telegraphs, ornately crowned and lit by a lamp. From here, the term "box alarm" originated and is still used today, though the system is no longer used. Fire alarm telegraphs were located in places with high risks of loss from fire. (HSW.)

Gamewell Fire Alarm Telegraph
Washington D.C. Fire Department

This is a close-up of the previous fire alarm telegraph, a technology that advanced Washington's fire service. The Victorian pedestal also complemented the streetscape and served as a miniature sidewalk museum to the industrial age. It is unknown whether these lamps were gas or electric. The first telegraph alarm took place on the old Crystal System from Box 42, located at Eighth and L Streets NW on October 21, 1864, at 12:01 a.m. The first box alarm received after the Gamewell system was installed was Box 61, located at the quarters of Engine 3, October 1, 1875 at 12:40 p.m. It is unknown if the previous was truly reporting fire, but the latter alarm was struck because a citizen needed assistance and the company was out of quarters. Ironically, there is no safeguard in place today to help the public should the company be out of quarters. (CFM.)

On July 1, 1864, the "paid" fire department of Washington began. Only four companies were paid at first. Five commissioners and a new chief engineer were appointed, and the name became the Washington City Fire Department. Engine 1 was organized from the Union Fire Company and placed in service at Twenty-first Street and H Street NW; Engine 2, formed from the Franklin Fire Company, was quartered in the volunteer house at Twelfth and D Street NW; and Engine 3 was located in the Columbia Fire Company house at New Jersey Avenue and B Street SE. The Metropolitan Hook and Ladder Company, later renamed Truck A, was quartered in 1879 in its volunteer house at 438 Massachusetts Avenue NW. This 1887 image shows Truck A. (Author's collection.)

The ending fire of the Civil War destroyed part of the Smithsonian's collection and may have begun by an incorrectly installed flue. It and an explosion at the Washington Arsenal were the last major fires involving the volunteer fire companies. For the next several years, few major fires occurred, due to fire safety inspections; development of fire standards, fire plugs, and the alarm telegraph; 24-hour staffing; and the firemen's ability to immediately respond. Recording of statistics began in the city the following year. In 1865, the total fire loss was $121,500, just over $1 per D.C. resident. The total number of fire alarms was 55; false alarms were rare. Incredibly, a century later, an engine company responded to 55 false alarms per month. (HSW.)

During this time, improvements were made to the municipal water system, and fire plugs were added. This "public pump," which survived until 1925, was a favorite of local children on hot summer days. Though not intended for use in the event of a fire, companies could connect to it or draft the large volume of water usually found in the neighboring horse trough. One of Montgomery Meigs's attempts at sprucing up the streetscape, this pump, located at Wisconsin Avenue and M Street in 1858, had threads capable of fitting a fire hose when a blind cap was removed. In the city were cisterns made accessible by the removal of a cover from the street. Inside was a tank of water capable of supplying up to three hard sleeves. This relic survives, along with crosscuts of wooden water mains, in the Bryant Street Pumping Station's water works museum. (D.C. Sewer Authority.)

Salmon P. Chase, Lincoln's secretary of the treasury during the Civil War, and his family were considered some of the most important socialities in the city. The house, built in 1851 and demolished in 1936, stood on the northwest corner of Sixth Street and E Street NW. Visible in front of the house is a Washington City fire hydrant; the almost indiscernible wooden fire plugs were the standard throughout most of the city. In the volunteer days, it was not uncommon for the first company to arrive at a fire to place barrels or similar objects over the plugs so the arriving rival fire companies could not establish a water supply and therefore could not fight the fire. (HSW.)

John H. Sessford, chief engineer in 1867, arranged this collage of Washington city firemen, both paid and volunteer. (JCG.)

By 1870, there were few or no volunteer companies, and in February of that year, an ordinance and act appropriated money for a fully paid department. Here, Engine 4's hose wagon and firemen stand in front of the Virginia Avenue station between 4 1/2 and Sixth Streets SW. The following year, the city took over the fire company in Georgetown as Engine 5. As the department now exceeded the confines of the city, the name changed to District of Columbia Fire Department. (JCG.)

This image of Seventh Street near D Street NW was taken 20 years after the paid department began. The department had seven engines and two ladder trucks, while the volunteers had eight engines and two ladder trucks. The congestion and complexity of the city, coupled with more than one building fire at any given time was a daunting task. The risk of major conflagration was eminent, and the nearest steam fire department was in Baltimore. It takes 39 minutes to get apparatus to or from Baltimore by train, as the department learned on July 25, 1873, when Baltimore requested assistance from D.C. Note that the city beautification project had not yet buried the utility lines, which made firefighting even more hazardous. (HSW.)

The paid fire companies consisted of four men each: the foreman, who was the officer in charge; the engineer, who was responsible for the boiler of the steam fire engine; the fireman, who answered to the foreman and was responsible for maintaining and driving the apparatus; and the hostler, who cared for the horses. There were six call men who reported to fires. The truck had three paid men: foreman, hostler, and tillerman, the latter being the driver of the rear of the long truck. Seven call men reported to the scene of fires. The four men assigned to the engines and the three assigned to the truck essentially worked every day of the week and were given time off only for an occasional dinner or lunch. It was not uncommon for these men to have as many as 10 children, a puzzling feat considering the men's schedules. Seen here is the old Vigilant Fire House and Henry Addison Engine Company, renamed Engine 5 of the D.C. Fire Department in 1871. Five years later, when the hose carriage seen at right overturned en route to a fire, five men were injured and one had to have a leg amputated. (JCG.)

As late as 1877, the department was still operating with five engines, one truck, and zero companies in Anacostia. Often times during large or multiple fires, the federal government's engine from the Navy Yard was called in to assist. There was no need for Baltimore's assistance until September 24, when the patent office caught fire. When the D.C. firemen responded and began an interior attack, they found the attic was alight, and began an exterior attack. Within 10 minutes, the entire department was there, including the Navy Yard. Within an hour all companies were repositioned to Ninth and F Streets NW to try to halt a major conflagration. A special request was made to Baltimore, and by mid-afternoon, four engines and two trucks were on the scene. Burning embers started another large fire on G Street, where two of the Baltimore engines were sent. By the end of the day, the fire was out and an evening parade of the Baltimore City Fire Department commenced on the streets as a thank-you gesture. (LOC.)

On February 7, 1904, D.C. apparatus were summoned by the Baltimore City Fire Department for a major conflagration during which the entire business section of the city, surrounding today's inner harbor, was destroyed. This disaster and others inspired D.C.'s strict building code, which mandated the use of masonry and low rise buildings. Throughout the next 120 years, 29 engines and 16 trucks were added, and 4 rescue squads were opened throughout the city. (JCG.)

One of the most influential groups organized after the Civil War was the Veteran Volunteer Firemen's Association of Washington (VVFA). Created in 1887 by former Washington City volunteer firemen, the group included mostly "exempt firemen" (men who were not drafted into the military because their position as firefighters was deemed more important) not hired by the paid department. The men demanded government pensions for their service to the city as firefighters before and during the Civil War. In 1892, the City presented the VVFA, standing at left, with the old Union firehouse, built in 1837, as a meeting hall. In this building, the men amassed one of the largest and most important fire museums ever created, with the brunt of the collection focusing on the volunteer days in Washington. In later years, the VVFA became a social organization, traveling across the country visiting similar associations or hosting them here. The VVFA never opened its membership to anyone except former volunteers. (HSW.)

When the last member of VVFA died, the collection was left to the Association of Oldest Inhabitants of Washington (AOI), an organization dedicated to uniting the city after the Civil War. Beginning in 1909, AOI cared for the collection and added other relics until the Union firehouse was demolished for creation of the International Monetary Fund's headquarters *c.* 1955. Funds from the building's sale and donations were earmarked for finding a new museum and preserving the collection. However, by 1960, most of it was either given away or had been acquired by the Friendship Fire Association, a group of dedicated local "fire buffs" whose mission includes serving refreshments to D.C. firefighters at the scene of a fire. In this image, several of the old-timers stand next to one of two city fire bells collected by the VVFA. (HSW.)

The Union Engine House and the Association of Oldest Inhabitants, are pictured *c.* 1911. The Friendship Fire Association holds about a quarter of the VVFA relics, and the rest are missing or in other such collections as Alexandria's Friendship Fire Company Museum or the Smithsonian. A large portion, including Benjamin Grenup's parade hat, was stolen from the District of Columbia Fire History Museum and Public Education Center in the early 1990s. This organization, located in the firehouse at 438 Massachusetts Avenue Northwest, was part of the D.C. Fire Department public affairs and fire prevention office. Despite an article in *The Washington Post* regarding the theft, no one was held liable nor an investigation conducted. (HSW.)

This Columbia hand engine, which killed fireman Benjamin Grenup, is the oldest piece of D.C. fire apparatus known to exist. Built by the John Rogers Company of Baltimore in 1850, it served the Columbia Fire Company until after the Civil War, when a volunteer fire company in Virginia acquired it. The VVFA, who purchased and returned it to the city in 1887, owned several pieces of D.C. fire apparatus with AOI, including Chief Belts's buggy, an early hand-drawn hose reel, and a 1905 American LaFrance steam fire engine. After the demolition of Union Engine House, the pieces were separated. Later, a title proved the apparatus were still in owned by Association of Oldest Inhabitants. (HSW.)

Firemen from Engine 11, Truck 6, and Battalion Chief 4 assist in removing the Columbia hand engine from their quarters onto a flatbed trailer for storage at Security Storage of Washington in 1999. Over the next few weeks, four apparatus, two massive bells, and miscellaneous small items were placed into storage to safeguard their future and well-being. The following year, the Capitol Fire Museum, Inc. (CFM) was founded to raise funds for preserving AOI's relics. CFM has begun proposals for the construction of a world-class fire museum in Washington. (CFM.)

In James Goode's book, *Capital Losses*, published in 1979 by the Smithsonian Institution Press, he states that three fireplugs surrounding Benjamin Grenup's grave and memorial are of 1857 vintage, but they likely were not used in D.C. It is likely that fireman Grenup's memorial plugs were imported from New York or Philadelphia. The iron fence surrounding the memorial reputedly came from the old Columbia volunteer house. Benjamin Grenup was the first but not the last fireman to die in the line of duty in D.C. While no one alive today knew Grenup, we all know of him, understand the pain his family and friends endured, and feel moved by his memorial. That anguish is felt today when a fireman dies—Grenup's memorial serves as a link between generations as a reminder that it was a dangerous job then as it is today. It is a reminder to be safe, but most importantly, to know that the fraternalism found among firemen lives through the ages. (HSW.)

Two
HOMES OF THE BRAVE
Engine Houses

In 1904, Chief William T. Belt, appearing top center, had another collage made showing all the men in the department as well as the firehouses. Many of these firehouses survive today and are from the eclectic period of firehouse architecture, inspired by styles seen at the World's Columbia Exposition in Chicago in 1893. Today there are 32 active firehouses of varying age. One awaits construction (E-20); three are empty, two of which belong to the city (E-12, E-6, E-10); one is a church (E-26); two are private residences (E-7, E-9); one is a clothing outlet (E-5); one is a restaurant (original E-5); one is a private industrial commercial space (T-4); and one is part of the Metro ventilation/utility system (E-24). From the lower left are the firehouses belonging the second Chemical 2 Engine 22: Truck 11; Truck E (5); Truck B (2); Engine 7; Engine 2 (a very short lived firehouse); Engine 8; Chemical 5 Engine 25 Truck H (8); Truck F (6); Truck A (1); Engine 10; Engine 16; Engine 3; Truck C (3); Engine 4; Engine 9; Engine 1; Engine 15; Engine 17; Truck D (4); Engine 5; Engine 11; Engine 14; Engine 12; and Engine 6. (JCG.)

The Union Engine House was one of oldest firehouses to survive from the days of the volunteers. Built in 1837 at Nineteenth and H Streets NW, it served the Union Fire Company until the Civil War when it became quarters for the federal fire department's fire company. Then it was returned to the city for use as Engine 1's quarters for the Washington City Fire Department until January 1867, when it was abandoned. In 1892, it was given to the Veteran Volunteer Firemen's Association as their meeting hall and museum, then transferred to the Association of Oldest Inhabitants in 1909, then was demolished c. 1955. The building also served as a public school (while an active firehouse!) and headquarters of the Union Guards, a local militia unit in the 1840s. (HSW.)

On January 5, 1867, Engine 1 was moved into its new firehouse at 1643 K Street NW. This Italianate firehouse set the tone for many Washington firehouses over the next several years. The tower, suggestive of the volunteer days when a bell would have been affixed there, later became a firehouse standard to be used for fire-watch and as a vertical space to dry hose. It is interesting to note that in this image the house is surrounded by private homes. The rails seen in the engine room floor in the left bay were to assist in guiding the steamer back into quarters. (JCG.)

Urban renewal was the blight of many old buildings after 1950, as seen in the case of this brick mask of bland design replacing the details of the previous façade. If the goal of firehouse architecture was to establish a relationship between the firemen and the community, then one must wonder what this building achieved. Winston Churchill once wrote, "First we shape our buildings, then they shape us." This one was demolished in 1960. (JCG.)

Here are Engine 1's current quarters, 2225 M Street NW, constructed in 1960. For many years, engine companies had separate quarters from truck companies, which usually shared their quarters with a battalion chief. Before and after World War II, because of budget cuts, the houses were co-inhabited by both engine and truck companies. Today a few firehouses contain only an engine company, but there are no single-truck houses. Truck 2 is seen here as well, having moved in with the battalion chief when the firehouse opened. Unfortunately, because of the combination, the fire department still assigns a confusing array of numbers to each company in a firehouse. Firehouses are rarely referred to by their community names, but rather by the engine company's number. (JCG.)

Engine 2 got its start as the Franklin Volunteer Fire Company at 1204 D Street NW, in a building similar in size and detail to Engine 1's quarters. It is likely that the same municipal architect designed both structures. In 1897, Engine 2 moved out and Chemical Engine 1 moved in. The Franklin Fire Company plaque can still be seen set into the street under the bench at Thirteenth and K Streets NW. The house was demolished during the Great Depression. (JCG.)

On January 5, 1897, Engine 2 moved into its new house three blocks from the old at Fifteenth Street and D Street NW. That firehouse was short lived as it stood in the way of federal development, and on November 9, 1910, new quarters were constructed for Engine 2 at 719 Twelfth Street NW. The wonderful Italian Renaissance firehouse was designed at a cost of $1,200 by famed Washington D.C. architect Leon Dessez. The triple doors were defined by rusticated arches, which were popular in the city during the Beaux Arts period and seen on many school buildings of the era. A third-floor gymnasium was included in the original design and was found behind the brick and stucco frieze, ventilated by the circular windows. Built for $40,000, the designs had originally called for twin towers on the sides of the building, but budget constraints prevented them. The firehouse was demolished because of Metro tunneling in 1979. (JCG.)

Similar in style to the FBI building, Engine 2's current firehouse was built at 500 F Street NW in 1979. Typical of neighboring construction, it acknowledged the lack of parking in downtown D.C. with a parking lot in the basement. Unfortunately, the structure suffers from Metro tunneling with rumors of sagging foundation, water leaks, and problems associated with deferred maintenance typical of the era when it was built. (DCFEMSPIO.)

Engine 3, credited as the successor to the oldest fire company in the city, the Columbia, had three firehouses before the Civil War. The above firehouse, built in 1875 by the D.C. Fire Department, was located at Delaware Avenue and C Street NE. It is more Victorian than the Union and Franklin houses, likely because of its proximity to the Capitol and wealthy surroundings. The house was demolished for development of the Union Station plaza after 1916. (JCG.)

Engine 3 moved into its current quarters at 439 New Jersey Avenue on November 26, 1916. This was one of the early horseless houses, though the department used equestrian power until 1925. The firehouse of Engine 3 is one of the most architecturally outstanding in Washington. (JCG.)

A history of Engine 3 would not be complete without an image of its faithful neighbor for many years, Number 6 Police Precinct. Police stations throughout the city were as architecturally endearing as the firehouses. The station stood at 437 New Jersey Avenue NW and was built almost four decades prior to Engine 3's quarters in 1916. In the 1920s, the station was the Number 6 Precinct Police School and also had sleeping accommodations for a reserve force in the event of civil unrest or extra duty. The clerical duties and officers from the station were moved to the municipal center at 300 Indiana Avenue before World War II, and the station was demolished. The firehouse had not been built yet when this photograph was taken. (Author's collection.)

This firehouse was built for the S.J. Bowen, known as the South Washington Fire Company, as part of the Washington City Fire Department in 1870. Located at Virginia Avenue and Fourth and a Half Street, it not only helped protect the Navy Yard but the hundreds of surrounding dwellings that were home to the many Navy Yard civilian employees. The house was occupied by Engine 4 until September 1940. It is interesting to note that this was the first all African-American fire company in Washington, organized in 1919, though African Americans had been part of the department as early as 1893. This represented the first major shift toward segregation of the department. (JCG.)

Engine 4 was relocated into this firehouse at 931 R Street NW in 1940. The firehouse, built in 1885, had quartered Engine 7 until that year when it was moved to a truck house in Southwest. The segregated companies disbanded by 1965. Note the "No. 7" medallion on the second floor front. Built to resemble neighboring structures, this a center block row structure, privately owned today. (JCG.)

Engine 4's new firehouse opened in 1976 to house Engine 4 and Rescue Squad 2. The latter is no longer assigned here, but the safety office is today found in Engine 4's firehouse, as is the special operations office. The house stands at 2531 Sherman Avenue NW in Shaw and is of masonry construction built to withstand the ages or firemen with limited funds for maintenance. (DCFEMSPIO.)

Engine 5 was the Vigilant Volunteer Fire Company of Georgetown until it was incorporated into the Washington City Fire Department. It appears this company was paid as far back as 1867, probably by the municipality of Georgetown. Images of the Vigilant firehouse are seen in the previous chapter; this image is the old Georgetown City Hall-cum firehouse, located at 3210 M Street NW. In 1883, Engine 5 moved into this building, which still stands today and is a privately owned retail space. Engine 5 moved into quarters with Truck 5 in July 1940. This building was earmarked for the Association of Oldest Inhabitants to move its collection into after 1955 when the Union Fire House was demolished for the International Monetary Fund. The dealings met a shortfall and another group, the National Capital Firefighting Museum, attempted to renovate the structure, which had been vacant except for pigeons for four decades. Unfortunately, guano removal alone nearly bankrupted them, and with little municipal or federal support, the idea was abandoned. The Capitol Fire Museum today owns the collection of the National Capital Firefighting Museum and has it in storage. (JCG.)

In 1940, the D.C. Fire Department began consolidating firehouses, and many of the single companies were combined into one house. In July 1940, Engine 5 moved up the hill to Dent Place to share quarters with Truck 5. (JCG.).

Engine 6 was desperately needed when it became part of the D.C. Fire Department in February 1879. This same year, a new firehouse for Truck Company A was constructed, and it moved out of 438 Massachusetts Avenue, where the ladder company had been for almost 25 years. Engine 6 moved in. The firehouse above was built in 1855 and is the city's only extant firehouse from the volunteer era. Larger than contemporary volunteer houses, it was capable of stabling horses and had sleeping accommodations in the former meeting hall on the second floor. The alley to the rear of this building is "Hook and Ladder Alley," named in 1859. (JCG.)

Engine 6 moved from the old house into this house with Rescue Squad 1 in June 1974. Shortly thereafter, Truck 4 was stationed here as well. This style of firehouse, typical of the era, was likely influenced by civil disturbance. It is constructed of masonry and steel, and though cold and mediocre in design, it will stand the test of time as long as the city funds regular maintenance. Note the streetcar tracks in the foreground; it had been out of existence for a decade when this picture was taken. (JCG.)

Engine 7, created in January 1885, was housed at this center row Victorian firehouse at 931 R Street NW. The image was taken October 8, 1907, for the International Association of Fire Engineers annual convention, as was the custom at the time. Today this is one of two city firehouses privately owned as residences. (JCG.)

In 1940, because of budget shortfalls, engine and truck companies were being paired up; one such instance was when Engine 7 moved into this firehouse with Truck 10. Located at 347 K Street SW, the building was never intended to house 12 men. The living quarters, parking, and kitchen space were limited. This firehouse was demolished during urban renewal in 1961. (JCG.)

Engine 7 was again relocated in 1961 to this firehouse built as part of the fire department repair shop. This was one of the few firehouses built in this era, two of which were located in Southwest as urban renewal took hold. The volume of historic buildings demolished at the time is astounding and has been well recorded in the annals of Washington history. Engine 7's firehouse architecturally reflects the mass housing projects in the area. Though built of masonry, the building suffers roof leaks and other minor problems easily alleviated with scheduled maintenance. (DCFEMSPIO.)

Engine 8 opened January 22, 1889, at 637 North Carolina Avenue SE. This location also found the original fire department repair shop and training school; the drill tower of the latter, built in 1902, can be seen in the background. This firehouse was a gift to the street and complemented, if not emulated, the nearby Eastern Market. Engine 8's firehouse, which was almost identical in size to Engine 7's, was also a center-block Victorian style–firehouse. Here, the firehouse is decked out for the International Association of Fire Engineers convention in 1907. Note the mascot—a goat! (JCG.)

The fire department training school enclosed the drill tower in 1928 to create a more realistic environment when "humpin' stairs" in high-rise buildings. Although D.C. had no buildings more than 13 stories, the height of the tower was enough to send men to their knees once they reached the top. The American LaFrance ladder truck, which had been Truck 15, did not flex after the tractor as ladder trucks do today, but its overall length required it to be tillered, or steered from the rear. In this image, recruits run a large diameter attack line up and into a window of the tower. A retired deputy chief at the time of this photo, c. 1940, says firemen had to wear dress uniforms during drills but were allowed to take off the jacket. Note the simplicity of the jack stands; it does not even appear they are in contact with the ground. These lightweight spring-loaded aerial ladders could be raised, rotated, and extended fully within 10 seconds. The drill school was used until December 1960, when the new Fire Training Academy in Southwest D.C. opened. (Author's collection.)

The fire department shop was built alongside Engine 8's firehouse in 1914. The shop moved to its new location in 1961, shortly after this photo was taken. Today nothing remains of the original shop, drill school, or Engine 8's old firehouse. (JCG.)

Probably the tidiest building and grounds in Washington, the D.C. Fire Department stables were located to the rear of Engine 8's firehouse. It is not known when the structure was built, but it was contemporary with the firehouse and capable of stabling about 20 horses. There were most likely accommodations for a goat as well. Recruits manicured the grounds, and all agreed the horses were the most revered warm-blooded creatures ever to set foot in a firehouse; their accommodations were often better than what the firemen regularly endured. (JCG.)

It was a seemingly sad day in 1914 when the horse-drawn era was coming to a close. In this view of the fire department shop, several horse-drawn combination chemical wagons stand at attention awaiting their final orders while a new motorized combination chemical wagon dresses them down. Though probably kept in reserve for a short while, the chemical engines were a godsend in areas without hydrants. The wagon closest to the camera is Combination Chemical Number 4. (JCG.)

Here is Engine 8's quarters today. Located at 1520 C Street SE, the building, opened March 25, 1964, has one level with a centered engine room. (DCFEMSPIO.)

Another stunning center block Victorian, the quarters for Engine 9 were built at 1624 U Street NW and opened September 6, 1893, complete with grotesques. This station was abandoned by the department and sold publicly in 1966, when Engine 9 moved across the street to its new firehouse. (JCG.)

A formidable fortress, Engine 9's new firehouse at 1617 U Street NW opened on October 24, 1966, the age of civil unrest. Most likely the architect and the department came up with such a design after having seen how susceptible buildings with large windows and doors were to the Watts Riots and other vandals. The answer was narrow windows, a concrete ceiling, and masonry walls. Though architecturally out of place with its somewhat exclusive neighbors, the bland firehouse design was better understood by the public two years later, when substantial riots struck the area after the assassination of Dr. Martin Luther King in April 1968. Like Engine 8, this is a single-story firehouse with a center engine room. To the rear of this firehouse is the Third District Police Precinct. (JCG.)

Engine 10's firehouse opened July 2, 1895, at 1341 Maryland Avenue NE. Following Engines 9, 8, and 7, this firehouse was yet another significant center block row firehouse meant to complement—and protect—its neighbors. Engine 10 remained in this Trinidad, D.C. firehouse until the consolidation of 1940 when, along with many other companies, it moved into the quarters of Truck 13. The building still stands today and of this writing, is in the city's inventory. Though suffering a lack of regular maintenance, it is in good condition and serves as a community center. (JCG.)

Engine 10 moved in with Truck 13 at 1342 Florida Avenue NE on June 4, 1940. The engine in this contemporary photo was the busiest engine company in the world for 10 years straight. (DCFEMSPIO.)

From 1885 until after 1900, the municipal architect–designed firehouses were similar style and size to their surrounding structures, or they were to inspire and influence new construction and a desired style of the neighborhood. Engine 11's quarters were designed by Leon Dessez. Located on the equally commercial and residential 3100 block of Fourteenth Street NW, the firehouse retained domestic and commercial influences. Notice the similarities to Engine 10's original firehouse. The firehouse was built in 1895 for Chemical Engine Company 2, which was essentially a large fire extinguisher on wheels; it was needed above the hilly outskirts of the city where there were few hydrants. Engine 11 moved in on July 1, 1897, and then into the quarters of Truck 6 on June 4, 1940. Several retired firemen claim that Engine 11's old firehouse was burned during the riots in 1968. (JCG.)

Engine 11 moved into Truck 6's firehouse around the corner at 1338 Park Road in 1940. Both companies moved into their new firehouse, pictured here, located in Columbia Heights at 3420 Fourteenth Street NW on June 5, 1984, along with Battalion Chief 4. (DCFEMSPIO.)

At the beginning of the city's period of eclectic firehouse design, Engine 12's Spanish Colonial firehouse began a tradition until 1916 of varying architectural styles for firehouses. It was designed by the municipal architect and built in the exclusive Truxton Circle neighborhood at North Capital Street and Quincy Place Northwest in 1897. Phil Ogilvie, retired archivist of the District of Columbia, states that when Boundary Street (today's Florida Avenue) was being repaved and regraded, an original city boundary stone was removed to the basement of Engine 12 for safe keeping, and was forgotten about for nearly half a century. After an exhaustive search of the building, it was never found, but is rumored to have been sealed into the basement near the Quincy Street steps. Engine 12 moved into new quarters in 1987, leaving behind one of the finest firehouses the city has known. Today it sits vacant and dilapidated with a haphazard coat of yellow paint that was illegally applied while awaiting a new occupant. It remains on the city's inventory as of this writing. (JCG.)

Engine 12 moved to 2225 Fifth Street NE on April 30, 1987, along with the Hazardous Materials Unit and Battalion Chief 1. Numerous buildings throughout the city were constructed in a style employed by many penitentiaries. Although not very attractive or architecturally charming, this style is certainly well built and designed to withstand heavy weather, civil unrest, and the toughest element of all—firemen and their fire engines. (DCFEMSPIO.)

Though Engine 13's firehouse should have been built in 1897, it did not open until November 1904. Some said it was awaiting congressional funding for specialized firefighting apparatus; others said the area was less affluent than other sections of the city. Still others claimed the city requested federal funds for fire protection of the wharf and incoming ships. The former explanation proved true, when in 1904, Engine 13 opened with not only a steam fire engine, but also a combination chemical engine. The firehouse was located at Ninth Street and G Street SW, serving the waterfront. Several spectacular ship fires had occurred here in the past and were likely influences for the company's technology. Engine 13 remained in this house until 1960. The firehouse has since been demolished during urban renewal. (JCG.)

Engine 13 and Truck 10 were paired up in this new firehouse on October 26, 1960, at 450 Sixth Street SW. This firehouse is atypical of the pre-riot houses, which were probably the best designs of the modern era as they are ergonomically correct: they did not have steps or poles, and were not architecturally offensive to the neighborhoods. The Foam Units are assigned here as well. (DCFEMSPIO.)

Engine 14's quarters served not only as a firehouse but also as headquarters for the fire department dispatcher for many years. It is interesting to note that the firemen would often tamper with the telegraph lines so they could hear all the boxes being received as opposed to only the ones sent out to the stations. Often times they would be on the scene of a fire before the other fire companies were even dispatched! This firehouse was opened on June 8, 1898, located on the short block of Eighth Street just above D Street NW. On June 14, 1945, the company moved into a new firehouse, the twin of Engine 26. Rescue Squad 1 moved into this old firehouse the following year for less than a decade. It has since been demolished. (JCG.)

Across from the Rock Creek Church Cemetery, where several D.C. firemen killed in the line duty are buried, is Engine 14's "new" firehouse, built in 1960 at 4801 North Capitol Street NE. This is practically the same firehouse as Engine 26, except that 14's firehouse was not built with the same aesthetics as were commonplace before the war. A mediocre style typical of the neighborhood, it too is a single-story structure with a center engine room. Rescue Squad 2 moved here as well when the firehouse opened, but has since been relocated. (JCG.)

Engine 15's firehouse bears a striking resemblance to Engine 14's original firehouse. Designed by the same municipal architect, the structures served at opposite ends of the city for nearly the same amount of time. This house opened April 15, 1898, at Fourteenth and V Street SE, formerly named Washington Street and Pierce Street, Anacostia. Note the house numbers are out of order in terms of their date of completion; this is probably because the construction was planned years in advance, and construction delays and work shortages were not taken into account. Engine 15 remained in this house until it was demolished in 1966. Then, the company was temporarily housed at Engine 32 for almost two years. (JCG.)

In 1968, Engine 15 moved into its new firehouse, built on the same grounds as the previous house after it was demolished. Again, typical of the period, the new firehouse was a single-story structure with a center engine room. Today it is home to Rescue Squad 3 and Battalion Chief 3 as well. (JCG.)

Engine 16 started in the old Franklin Fire Company house at Twelfth Street and D Street NW on October 24, 1904 (see page 34). A chemical engine had occupied the building after Engine 2 left and before Engine 16 arrived. Engine 16 was the last to occupy that firehouse, which was demolished during the Depression. Then, Engine 16 moved into the quarters of Truck C. Engine 16 moved into a new firehouse, the "big house" (seen above), on January 16, 1932, and remains there today with Engine 16, Truck 3, and Battalion Chief 6. Designed by Albert L. Harris, the city municipal architect, the Colonial revival firehouse is a showpiece in the city and is the only one with four apparatus bays. It is also the only firehouse containing glazed brick in the engine room, a surface designed for easy cleaning in the age of motorized apparatus. The upper walls of the engine room contain a bas-relief trim of chevron pattern, a rare treasure in firehouses today. The third floor originally housed the police and fire clinic, complete with operating room, recovery room, laboratory, and meeting room, capable of accommodating six doctors and numerous patients. (JCG.)

Located in Brookland, this Italianate building was probably influenced by the mostly Catholic neighborhood. Engine 17 moved here on April 22, 1905, but its firehouse was constructed in 1902 for Chemical Engine Company 4, which was disbanded three years later. The architect was likely Snowden Ashford, who also designed Engine 25's firehouse. The four-story tower serves as space for drying hose and as a watchtower for fires. Towers predominated during the eclectic period, likely because of concerns over failure of the fire alarm telegraph system. The station is still home to Engine 17. (JCG.)

Engine 18 was created on November 18, 1905, and moved into this firehouse designed by Leon Dessez at 1001 Ninth Street SE. This building's similarity to others before it indicates they were designed by the same architect. During the consolidation of 1940, Engine 18 was moved into the quarters of Truck 7. Pairing up firehouses was thought, or perhaps hoped, to be a temporary change during the budget crunch. As such, the companies' numbers were never changed. Today many firehouses have an engine and truck with two different numbers, and a firehouse named only for the engine company stationed there. Engine 18 returned here for a short time in the mid-1960s, when the firehouse it was occupying with Truck 7 was demolished, and another was built on the site. This firehouse was demolished before 1970 for construction of the Southeast Freeway. (JCG.)

Engine 18 and Truck 7 have occupied this firehouse located at Eighth and D Streets SE since it was built in April 1965. The two-story design is in stark contrast to much of the outstanding architecture found in the neighborhood and Marine Barracks. The firehouse was built to serve a purpose though: it is home to able bodied firefighters who faithfully deliver their services to the community. (JCG.)

Washington D.C. had two waterfronts catering to commercial vessels and industry, but only one municipal pier. Through the years, there had been several ship fires as well as vessels that sunk because no one could assist with de-watering pumps. The potential for a major waterfront fire was extreme. In this image is a massive ice pack in Georgetown that often caused flooding in town; below is a turn-of-the-century side-wheeler fire that was inaccessible to fire engines. It was time for a fireboat capable of breaking ice as well. Begun in December 1905, the fireboat "Firefighter" was called Engine 19, as it was essentially a fire engine on the water.

The city owned a municipal pier located at Seventh and Water Street SW, where a building housing the crew of the fireboat was stationed. Pictured here after its completion in 1905, it is not uncommon to see images of this building inundated with flood waters several feet deep. It is also interesting that this building not only housed the firemen, but also the city's morgue. While extensively researching the train wreck in Terra Cotta D.C., which occurred a year after the building's completion, the author found that the first floor was occupied by the morgue. One of the duties required by the men of the fireboat was assisting the morgue master with moving dead bodies; after the train wreck, as many as 35 bodies were brought here by the firemen to await positive identification by relatives. The morgue was housed here because the wharf offered an endless supply of ice for cooling the cadavers. (JCG.)

In 1946, the U.S. Coast Guard got rid of the pier at Maine Avenue and N Street SW (550 Water Street after urban renewal), and the firehouse for the fireboat was occupied. Note the dinghy tied to the side of the building; this was a necessary measure due to the winds off the pier that exceeded 10 knots. When the fire department acquired this pier, it was decided that the police harbor patrol would share the building; it does so to this day. This structure was demolished in the 1980s for a modern facility that included a heliport, pictured below. In the past several decades, it is not uncommon for flood waters to rise as much as three feet over this concrete pier. (JCG.)

The fireboat station today is a modern facility shared with the Metropolitan Police Harbor Patrol. D.C. has the only fully staffed fireboat in the region capable of fighting fires, de-watering sinking vessels, mitigating pollution spills, managing aircraft emergencies, conducting swift water rescue, searching for and rescuing drowning people, and intervening in an assortment of minor injuries and fires attributed to the thousands of recreational boaters, fishermen, and visitors to the rivers daily. It is common for their specialized service to be called upon as far south as Charles County, Maryland, on the Potomac River, or as far north as Bladensburg, Maryland, on the Anacostia River. (JCG.)

Perhaps one of the best loved firehouses, Engine Company 19's firehouse was built for $26,000 in 1910 at 2813 Pennsylvania Avenue SE, in Randle Heights. The firehouse initially housed a chemical engine company, which disbanded in 1920 when Engine 19 moved in. The land, called Randle Highlands, was donated by Col. Arthur E. Randle, who hoped to spark new home construction to the area. Located midway up the steep avenue, the towered French Eclectic firehouse offered an unobscured view of Anacostia all the way to Gieseboro Point. Engine 19 remains there today, and the building retains nearly all of its original charm including hardwood floors on the second level. Originally, the building was of brick, but likely changed to stucco to reflect the Beaux Arts movement popular at the time. (JCG.)

When it opened in 1901 for Chemical Engine Company 3, this Italianate firehouse was the first freestanding firehouse since the era of the volunteers. Architect Leon Dessez designed seven other D.C. firehouses. Engine 20 arrived in 1907, when Chemical 3 was disbanded. Truck 12 was also housed here in an addition on the north side in 1913. Both were here until 2002, when the neighborhood called for the house's demolition, claiming the building was structurally unsound. Preservationists said it was sound but filthy and agreed to an expansion if residents and officials would help preserve it. Residents and the firechief, fearing political turmoil, approved the demolition. Preservationists asked that the façade be incorporated into the new design, which was approved; however, the construction company suffered financial trouble, and the site remains a hole. Engine 20 and Truck 12 have relocated to neighboring parts of Tenleytown. (JCG.)

Engine 21's firehouse at 1763 Lanier Place Northwest was completed in 1908. Designed by architect Appleton P. Clarke, it was likely financed by the owner of the luxury Ontario Apartments. The owner also convinced the city to build a lunette window with a clear view of the Ontario Apartments, so firemen could watch for fires. Built prior to most homes in this area of Adams Morgan, the firehouse influenced the Mediterranean revival style the neighborhood. The department planned to demolish the firehouse in 1975, but neighbors prevented it. The building was restored in 1983 and reopened as a neighborhood landmark. (JCG.)

In 1897, this firehouse was built for the second Chemical Engine Company 2 at 5760 Georgia Avenue NW in Brightwood. In 1907, Chemical 2 was upgraded into a combination chemical engine and ladder truck, but in 1908 was disbanded for creation of Engine 22 and Truck Company 11. One story was added for the truck. The firehouse is the oldest municipal firehouse in use in the city and the second built during the eclectic period. Its style is Italian Renaissance revival. Years later, a second floor was built above the truck addition. Like most D.C. firehouses, the building suffered through immense cut backs, but it has recently been renovated. The firehouse is still used by Engine 22 and Truck 11.

Engine 23's firehouse was designed as an arts and crafts interpretation of the Italian renaissance revival style. Designed by local architects Hornblower and Marshall, it was built in 1910, when Foggy Bottom had been developed for almost a century. It is D.C.'s narrowest firehouse; a rear door enabled the engine to drive through rather than backing in. At one time, the interior contained three circular staircases. In 1940, rumors of demolishing the building for a new library were squashed by residents. Instead, a new library was built and the firehouse remained. (JCG.)

This Italian Renaissance revival firehouse was built in 1911 for the first motorized fire company in Washington, Engine 24. Located at 3702 Georgia Avenue NW, the firehouse was established literally in the crossroads of the community, at Georgia Avenue, New Hampshire Avenue, and Rock Creek Church Road. Like Engine 22 farther up Georgia Avenue, this building also was designed without side windows in anticipation of commercial buildings surrounding it, though it retains all the charm of a center block firehouse in a residential neighborhood. In the mid-1990s, the Metro informed the fire department that Engine 24 was located in the middle of their proposed Petworth Station, and the building would be demolished. Preservationists were outraged, as the significance of the firehouse far outweighed the need for its demolition. At the Historic Preservation Review Board meeting, a Metro official claimed that the new station would, one day, be architecturally significant, and therefore there was no reason to preserve the firehouse. Renowned preservation Sally Berk was determined; she put forth a proposal for "facadomy," which is now a standard substitute to demolishing important old buildings. Though the fire chief at the time and many others, frightened they would not get a new firehouse, continued to call for Engine 24's demolition, rational planning and cooperating with the Metro saved the old building. The building stands as a landmark in the community and serves the Metro as part of a ventilation shaft. (JCG.)

Engine 24's new firehouse in Petworth is shared with Rescue Squad 2 and is part of a grand scheme to move fire companies farther out toward the Maryland line; this plan has been in place since the early part of the 20th century but has slowly been acted upon. The distance between Engine 24's and Engine 22's firehouse is less than a mile on Georgia Avenue. Engine 24's new firehouse is the finest new firehouse built in the city since the 1950s. Its domestic feeling encourages the firefighters to take good care of it, as it is their home away from home. The institutional style of other recently built firehouses has the opposite effect—some of them are fairly new but in dilapidated condition. (DCFEMSPIO.)

Another example of the Italianate style, this building was constructed in 1902 to house Chemical Engine Company 5. It was designed by renowned architect Snowden Ashford. Like Engine 17, the tower is used to dry the firehose and affords a view of Congress Heights. Ashford may have been inspired by Saint Elizabeth's Hospital nearby; he included a similar terra cotta roof. Truck 8 was stationed here in 1904 with the chemical engine. Engine 25 still uses this firehouse, but the truck moved a mile away to Engine 33 when it opened in the mid-1980s. When the firehouse was renovated, the center door, an important element of its style, was closed in. This firehouse is in good condition, but like all others, it suffers from lack of regular maintenance and professional cleaning. (JCG.)

Opened on September 18, 1908, the Tudor firehouse was built for the second Chemical Engine Company 3 in the Langdon neighborhood at 2700 Twenty-second Street NE. It became the quarters of Engine 26 on July 9, 1913, and then in 1940, Engine 26 was moved to the quarters of Truck 15, and this firehouse abandoned. It was sold to the public and still stands today as a church. Although the neighborhood was settled when this firehouse was built, it nonetheless inspired new construction of similarly sized buildings. (JCG.)

Engine 26 moved to the firehouse at 1340 Rhode Island Avenue NE on June 10, 1940. Nicknamed "the farm," it is a Colonial revival style designed by Nathan Wyeth. Engine 26 was built before World War II. Engine 26 and Truck 15 are still located in this building, though it is less than a mile from Engine 12; Engine 26 and Truck 15 are slated to someday be moved farther out toward the Prince George's County line. A new bunkroom was added after 1940 to accommodate the additional men. (JCG.)

Located at 4201 Minnesota Avenue NE, this firehouse opened January 16, 1908, for Chemical Engine Company 1 (this was the second time this number was used to designate a chemical company), which was disbanded in 1914 when Engine 27 moved in. Designed by architect Leon Dessez, the building was another Italianate design. Although few residences were in Benning in 1908, the firehouse protected millions of dollars of railroad freight yard a short distance away. A small neighborhood grew up around the modest firehouse, but the area was predominately commercial. The firehouse is in good condition today but has suffered years of deferred maintenance. (JCG.)

Engine Company 28 was placed in service January 1, 1916, at 3522 Connecticut Avenue NW. Much of this block of Connecticut Avenue was industrial—the Ginechesi quarry, now the location of the Uptown Theater, churned out blue granite. The masonry wall behind the firehouse uses the stone. In June 1926, Truck 14 moved into this firehouse as well, and Battalion Chief 5 is currently stationed there, too. (JCG.)

Engine 29's Palisades quarters were designed by municipal architect Albert L. Harris and opened in 1925 at 4811 MacArthur Boulevard NW, formerly Conduit Road. It was the first firehouse constructed after World War I and was the city's first single-story firehouse, called a "bungalow enginehouse" by writers in the *Washington Evening Star*. It was also the first to include a kitchen in its original design. Engine 29 and Truck 5 are stationed here today. (JCG.)

At a dress rehearsal for opening day in Deanwood, the men of Engine 30 and Truck 17 line up a week before the dedication on May 19, 1955, in front of their new firehouse at 50 Forty-ninth Street NE. Countless hours went into re-writing box alarms assignments, running routes, response cards, and the like in anticipation of this company opening in upper Northwest. Engine 30 was originally slated to open by 1930 at Sixteenth Street and Webster Street NW— an exclusive neighborhood that complained about the noise and ruckus a firehouse would produce. (JCG.)

Engine 31 is essentially Engine 29 built backwards, with a little more brick fence and cast iron work, and smaller fan-lights and hose tower. Both were designed by architect Albert L. Harris. The Colonial revival firehouse was built in 1930 at 4930 Connecticut Avenue NW and exemplifies the current administration's process for correctly renovating and restoring firehouses. The interior has heavily beamed ceilings unseen in other D.C. firehouses. The construction was funded after the refusal of the house on 16th Street. The upper belfry was removed for structural damage before 1975. A fireman weathervane sits on top today. (JCG.)

Engine 32's firehouse, nicknamed "the House of Glass," was opened on October 12, 1957, at 2425 Irving Street in the far reaches of Southeast. Rescue Squad 3 was organized and moved in the following year until 1965. Truck 16 was assigned here shortly thereafter. Much of this area was developed during World War II for government workers, though new construction is common today. (JCG.)

Opened in January 1987, Engine 33 was located at 101 Atlantic Street SE as part of the jumbled department realignment that intended to close or move Engine 25's firehouse. However, Engine 25 is to this day one of the busiest firehouses in the city. Truck 8 moved from Engine 25's firehouse into this larger firehouse with Engine 33 the same year. Though the area is known as Congress Heights, firefighters refer to this area as "the Valley." This firehouse had been planned for Engine 3, but Congress refused to allow them to leave Capitol Hill. (DCFEMSPIO.)

Saint Elizabeth's Hospital opened in 1851 to serve patients with mental illness and soldiers from the Civil War. The bucolic grounds and striking views of the city were considered part of the healing process. The grand campus has this impressive firehouse, styled in Florentine Quatrocento. Built in 1890, the station housed a steam engine responsible for protecting the grounds and many buildings on both sides of today's Martin Luther King Avenue. The station was moved in 1905, and the firemen were only allowed to use the lower floor. The upper floor was accessed through the tower as a place of respite for the groundskeepers. In later years, the firemen had full run of the house, installing a fire pole between floors and a bunkroom and offices on the second floor. The first emergency telephone system in the United States was installed here and remains in a first-floor office. Originally, the apparatus door was arched but has been modernized. The city was given control of this firehouse and much of the campus before 1990 and renamed the firehouse Engine 34. By 1994, the engine was removed for use in the city, and the firemen responded to calls in a utility truck for a short time until placed out of service. The station is on D.C.'s property inventory, but its future use is unknown. (JCG.)

Three
HOMES OF THE BRAVE
Truck Houses

Pictured leaving Truck C's firehouse is the only horse-drawn water tower the department ever owned. Trucks in the city were originally assigned letters as opposed to numbers, but in 1906, with the department's use of telephone and Morse key hook-ups in fire alarm telegraph boxes, the system began using numbers for engines and trucks. In the early days, trucks were quartered separately from the engines though they usually shared a house with the battallion chief. The first two battalion chiefs were former foremen of the truck companies. Engine companies needed two teams of horses: one to pull the steam engine and the other for the hose wagon. Truck companies required two or three horses to pull the apparatus, and the chief's buggy required just one horse. The Great Depression followed on the heels of the horse-drawn era, and during the budget crunch of 1940, reorganization and consolidation of the fire department and firehouses was necessary. (JCG.)

The members of Truck A pose in front of their firehouse built in 1879 on Capitol Hill, located at North Capitol and B Street NE. This was the second firehouse for Truck A; when the company was organized in 1855, it was quartered in the old Metropolitan Hook and Ladder firehouse at 438 Massachusetts Avenue Northwest. Truck A was renumbered Truck 1 in 1906 and was moved into a new firehouse with Engine 3 in 1916. (JCG.)

This image was taken shortly before Truck 1's firehouse was hammered into rubble to make way for the Union Station plaza. The stained glass and company medallions did not survive. Notice the upper windows were removed by salvagers or safety minded demolition crews. The firehouse was the last building standing the day of demolition. The wagon in front carries spools of electrical wiring probably salvaged during the demolition process. (JCG.)

Here are Engine 3, Truck 1, and the Battalion Chief shortly after moving into their new firehouse at 437 New Jersey Avenue NW in 1916. This was one of the early horseless firehouses. The firehouse was closed due to political agendas and budget cuts by 1993. Engine 3 reopened in 2000, though at this writing, many are awaiting the return of Truck 1. (JCG.)

The design of Truck B's firehouse, opened in January 1879, is attributed to John Fraser, who likely also designed Truck A's quarters, as well as the firehouses belonging to Engine 1, 2, and 4. The firehouse was located at 1181 New Hampshire Avenue NW, near the intersection of M Street. Battalion Chief 2 was located here for many years as well. (JCG.)

In 1906, Truck B was renumbered as Truck 2. In 1940, the department considered consolidating Truck 2 and Engine 1 into one house, but size prevented it. In the third bay at right is a reserve ladder truck. From the left are Capt. H.M. McLearen, Sgt. J.R. Arendes, Pvt. O.H. Tornquist, Pvt. W.J. Murphy, Pvt. A.P. Robey, Pvt. R.A. Jacobs, Pvt. H.W. Poe, Pvt. R.R. Francis, and Pvt. R.M. Smith. In October 1960, Truck 2, Battalion Chief 2, and Engine 1 moved into a firehouse built at 2225 M Street NW. Truck 2's old firehouse was razed the same year. The stained-glass window seen above the center door is in the collection of the Capitol Fire Museum. (JCG.)

Truck Company C was placed in service at the largest firehouse of the time, opened in 1891 at Fourteenth Street and Ohio Avenue NW along with the first Chemical Engine Company 1 and a new Battalion Chief. This striking firehouse became as much as a tourist destination as the Smithsonian Museum on the Mall. Notice how the building follows the angle of the street. The Victorian details were worthy of a Dupont Circle address at the time. (JCG.)

Here, in front of Truck C's firehouse, is the 75-foot Champion water tower built by the International Fire Engine Company for the D.C. Fire Department. The image existed in a encyclopedia contemporary with the tower's existence. (Sasher Collection.)

This is the last line-up at the Big House, taken days before everyone moved out in 1932. On the far right is Captain Sutton, who later went became fire chief. Thirty-five years before this photograph was taken, the chemical company moved out in 1897 and in 1901, a water tower moved in. In 1906, Truck C was renumbered as Truck 3. In 1931, Engine 16 moved into this house because its old one stood in the way of federal development; a little over a year later, the engine, truck, water tower, and chief moved to the new big house at 1018 Thirteenth Street NW. The original D.C. big house was demolished shortly thereafter. The water tower was obsolete and decommissioned 1956, as all truck companies had a ladder pipe. (JCG.)

Truck Company D, probably designed by Leon Dessez, was desperately needed when it finally opened in the city on March 1, 1896, at 219 M Street NW. During the era, it was not uncommon for the entire department to turn out to fight a single fire with no other resources available. The only option was calling for assistance from Alexandria or Baltimore. Many buildings burned at this time, not because of the firemen's actions, but rather because the city failed to mitigate the apparatus shortage problem. This image dates to after 1906 when the company was renamed Truck 4. The firehouse changed little during that first decade. Truck 4 remained in this firehouse past the consolidation of 1940 until it moved into what became the "modern big house" in 1975, which included Engine 6, Rescue Squad 1, a chief, and an ambulance. Truck 4's old fire house remains standing today and is privately owned. (JCG.)

Firemen of Truck 4 line up in 1923 for a photograph. The truck is a American LaFrance, capable of being fully raised, extended, and rotated in fewer than 10 seconds. From left are Lieutenant Chapman, Private White, Private Murphy (who later went on to become fire chief), Private O'Neil, Private Curtis, Private King, and Private Raely. The life net, folded in half and stored on the side of the truck, was a standard device on all truck companies up until the early 1960s. (Author's collection.)

Truck E was established in Georgetown on November 12, 1900, in a firehouse at 3412 S Street NW, later renamed Dent Place. It was reassigned the number 5 in 1906, and like other firehouses designed by famed architect Leon Dessez, this Burleith building encouraged new development in the neighborhood and influenced the style. Notice in this c. 1910 image the firehouse stands alone; today it is the center row house in the block and one of the best examples of how well a firehouse can blend in with its neighbors. In 1940, Engine 5 moved from M Street in Georgetown into this firehouse, and a few decades later, Truck 5 moved into Engine 29's firehouse while renovations were taking place; this firehouse was obviously too small to house both companies, and they have yet to return. (JCG.)

Built in 1901 at 1338 Park Road NW, Truck F's firehouse was designed by Leon Dessez and inspired new home construction in the exclusive Columbia Heights/Mount Pleasant community. Engine 11's and Truck 6's firehouses were a few blocks from each other, and this may have inspired construction of the massive Tivoli Theater at 3301 Fourteenth Street NW, built in 1924, two years after the Knickerbocker Theater collapsed a mile away, killing almost 100 people. Theater owners knew customers would feel more comfortable with two of the best fire companies in town next door. In the consolidation of 1940, Engine 11 moved into the quarters of Truck 6, and the two companies remained there until June 5, 1984, when a new firehouse was constructed for Battalion Fire Chief 4 and them. The old house number "1338" hangs on a wall in the dining room. At this writing, the old truck house still stands on Park Road and is on the city's inventory awaiting a new user. (JCG.)

In 1904, Truck Company G was placed in service at this firehouse at 414 Eighth Street SE, another Leon Dessez design. In 1906, the truck was renumbered Truck 7. In this 1911 photo, the horse's double hitch for the truck is barely discernable on the left, and the single hitch of the chief's buggy is seen at right, waiting to be fitted around an anxious horse. The horse's stalls were likely in the rear of this house, as it was standard for each horse to have its own window. The firemen were not so lucky. Wooden chairs seen in front are renowned as "firehouse chairs" and were standard in firehouses across the country into the 1970s. In 1940, Engine 18 moved into this firehouse with Truck 7. In 1964, the firehouse was demolished, and a new firehouse was built on the same location. Engine 18 and Truck 7 are stationed there today. (JCG.)

Truck H went into service in 1904 with Chemical Engine Company 5, which later became Engine 25, at 3203 Nichols Avenue Southeast, today's Martin Luther King Avenue. It was renamed Truck 8 in 1906 and was joined by Engine 25 when the chemical engine was disbanded. In this 1910 image, the quaint setting complete with windmill was typical of the bucolic lifestyle once prevalent outside the city. The trolley is just about at the turn-around of the Congress Heights line. Half a century later, the climate of the neighborhood changed, and this became the busiest firehouse in D.C., nicknamed by local media "the house that runs and runs and runs." In 1987, Truck 8 moved in with Engine 33 at 101 Atlantic Street and remains there today. (LOC.)

Truck 9, the first unlettered truck, went in service in 1908 alongside Engine 21 at 1763 Lanier Place NW. The fledgling neighborhood grew up around this firehouse, which was built in part to safeguard the Ontario Apartments located behind it. In the early days, before traffic, airplanes, and people created a constant hum, it was not uncommon to hear late at night the sounds of the wild animals at the National Zoo. In describing the firehouse's proximity to the zoo, one fireman said, "it is only a two-iron shot from the firehouse." On numerous occasions, the midnight roar from the lions' den or trumpet from the elephant's cage would rouse an unsuspecting fireman from bed, who would then run through the firehouse, panicked and shouting about wild animals on the loose! From the left are Lieutenant Taylor, Sergeant Weisner, Private Bailey, Private Stein, Private Phelps, Private Collins, Private Ward, Private Putnam, Private Anthony, Private Fenton, Private Hopeman, Private Souza, Private Smith, and Private Watkins. Today Truck 9 is located nearby at the larger firehouse built for Engine 9 on U Street in 1966. (JCG.)

Truck 10 was stationed at 347 K Street SW on March 31, 1910. In 1940, Engine 7 moved in. In 1960, Truck 10 moved to a new fire house with Engine 13 at 450 Sixth Street SW, leaving Engine 7 behind until its new firehouse was opened on December 9, 1961, on Half Street Southwest. The segregated fire companies in the city consisted of four companies: Engines 4, 7, and 13, 27, and Truck 10. African-American firefighters were only allowed on their respective apparatus and were not allowed to be detailed to a white company even when the roster was full. (JCG.)

Truck 11 went into service in the far reaches of the city in December 2, 1908, replacing a myriad of chemical and chemical combination engines stationed there since the firehouse was built in 1897. Engine 22 went into service in this firehouse in 1908 as well. Although the area was sparsely populated, the area this truck responded to was enormous and still is. It was not uncommon to have an additional horse in ready reserve here. Both companies still inhabit this firehouse, seen here shortly after World War II. (JE.)

Truck 12 went into service July 7, 1913, at Engine 20's firehouse located in Tenleytown at 4300 Wisconsin Avenue NW. The house was expanded to accommodate an early and somewhat experimental electric model apparatus that fared poorly in the muddy streets and lengthy hills of upper Northwest. This image was taken when the department decided to go back to the trustworthy standby, seen here racing out of the truck bay to a report of fire in 1914. The ladder truck is a reserve that had previously belonged to Truck 5. The horses are just starting their run, and by the time the tillerman left the house, they were at full pace. Some of the last remaining evidence of the horse-drawn days was located in the truck bay of the firehouse, which has since been demolished. Engine 20 and Truck 12 are awaiting a new firehouse at this writing. (JCG.)

Placed in service on December 9, 1925, Truck 13's firehouse is located at 1342 Florida Avenue NW, just around the corner from Engine 10's firehouse. In 1940, the two companies consolidated into Truck 13's firehouse and have been there ever since. This has been one of the busiest firehouses in the United States for many years. Engine 10 held the title of "busiest in the nation" for a decade. It is a title only a select few can tolerate. Firemen could expect to respond to as many as 30 calls per shift. The firehouse today is in good condition despite the firemen having little time for maintenance. The tower has been cropped off due to settling, and the elements taking their toll. The firehouse was designed by the architectural firm of Parks and Baxter in a Colonial revival style. The interior was unlike any seen in Washington before: the engine room towered to the second level, where around the perimeter was a mezzanine balcony and railing. Two-person bedroom suites opened onto the balcony, where fire poles were located.

Truck 14 went into service on June 15, 1926, alongside Engine 28 in the firehouse at 3522 Connecticut Avenue NW, constructed in 1916. (JE.)

In service on April 21, 1937, this was the last truck house built in the city. It was for Truck 15 at 1340 Brentwood Road NE, which later became Rhode Island Avenue. Engine 26 moved in three years later. An addition was built to accommodate more beds and lockers. Here, a fireman from Truck 15 is at the watch desk, located between the bays on the apparatus floor. The bell in the front is the house gong, rung to call men to line up or to announce the arrival of the chief. The blackboard was used to keep track of oil changes and other preventive maintenance. A joker tape, bells, and vocal alarm are on the desk. (JCG.)

Truck 16 was organized and placed in service on May 4, 1945, with personnel from Engine 27, which was reorganized as an African-American company. Truck 16 was originally quartered with Engine 19 at 2813 Pennsylvania Avenue Southeast, but today is located at Engine 32's quarters at 2425 Irving Street SE. This c. 1955 photo includes, from left to right, the following: Battallion Chief Best, Captain Boss, Lieutenant Ritnour, Sergeant Mattare, Sergeant Maier, Sergeant Burns, Private Reasebeck, Private Plass, Private Smith, Private Taylor, Private McVey, Private Beall, Private Gately, Private Ickes, Private Law, Private Mullican, Private Padgett, Private MacDanel, Private Grugan, Private Hall, Private Forsht, Private Schaefer, and Private Shelton. (JCG.)

Truck 17 was the last truck placed in service in the city on March 27, 1955, in Marshall Heights, D.C., located at 50 Forty-ninth Street NE with Engine 30. After the early 1990s when Truck 1 was closed, the city had 16 remaining active truck companies. This one is deemed one of the more important truck houses in the city, which was proven during the budget and apparatus shortfalls of the mid-1990s when a truck was kept here at all times, even though as few as four were available in the whole city. (DCFEMSPIO.)

Four
RESCUE SQUADS AND BOXES

In November 1947, Rescue Squad 2 lines up in front of Engine 14's firehouse for inspection. First aid, breathing apparatus, cutting torches, ropes, jacks, and other modern technology line the driveway. Following the lead of the New York Fire Department a decade earlier, the D.C. Fire Department created a Rescue Squad 1 to mitigate any rescue situations in January 1925. Before that time, truck companies were responsible for such specialty as rescues from train wrecks, automobile accidents, drownings, entrapments, and electrocutions. The squads rescued trapped citizens or firemen in a fire. During the flu epidemic of 1918, six firemen died in the line of duty from contracting the illness. Hundreds died in the city, and ambulances were overrun and unavailable. It was decided the rescue squads would also have an ambulance, intended for injured firemen. (JCG.)

Rescue Squad 1 was first housed with Engine 2 at 719 Twelfth Street NW. In 1946, it was given its own firehouse at 413 Eighth Street Northwest, the former quarters of Engine 14, which had moved out a year earlier. This was a rare occurrence but needed, as the squad's tools and the ambulance were suffering a shortage of space at Engine 2's firehouse. Rescue Squad 1 has been back in Engine 2's firehouse since 1953. No longer part of the rescue squad, the ambulance service is a civilian service today. Presently, the department is hashing out the problems with a lack of ambulances and inaccountability; it wishes to reorganize the agency so it is operated by sworn members of the fire department. (JCG.)

Both Rescue Squad 2 and its predecessor were created in part because of the collapse of the Knickerbocker Theater and the lack of specialized tools for mitigating such an incident. No rescue squads were in service when the theater collapsed, but just five years later, two came into being. Rescue Squad 2 was stationed practically next door to the massive Tivoli Theater at the quarters of Engine 11 at 3119 Fourteenth Street NW. Initially, it was a combination squad/engine company in service under the auspices of Engine 11. Manpower for the squad was pooled from Engine 11 and the battalion. In 1940, the consolidation of firehouses resulted in a very crowded firehouse with Rescue Squad 2, its ambulance, Engine 11, and Truck 6 all stationed together. Relief came in 1945 with the opening of a new firehouse at 4801 North Capitol Street NW for Engine 14, where the now bona-fide rescue squad and its ambulance moved the same year. Rescue Squad 2 today is located at the quarters of Engine 24. (JCG.)

This photo was taken shortly after the new firehouse at 2425 Irving Street SW opened in 1957. Rescue Squad 3 officially came into service on June 14, 1958. By this time, the ambulance service was not considered a necessary appendage of the rescue squads, as they were organized under the hospitals and health department. Only Rescue Squad 1 and 2 had ambulances, and the men staffing them were firefighters first, ambulance attendants second. Rescue Squad 3 today is located at the quarters of Engine 15. (JCG.)

Rescue Squad 4 was desperately needed when it went into service on at the quarters of Engine 31 at 4930 Connecticut Avenue NW. One of the critical missions of this company was swift water rescue in the turbulent class five waters of Little Falls, D.C., as well as in the often rain-swollen Rock Creek. Covering an enormous area from Rock Creek Park to much of upper Northwest down toward the Adams Morgan community, members of Rescue Squad 4 were lifesavers at many fires and vehicle entrapments, common along the dangerous stretch of the Clara Barton Parkway and other major roads. Disbanded due to management shortfalls and budget cutbacks in 1993, some of the rescue devices, such as the Hurst tool, have been transferred to neighboring engine and truck companies, as is typical in the counties' volunteer firehouses. Here are Rescue Squad 4 and Engine 31 shortly after the squad went into service. (JCG.)

The fire alarm headquarters had been located in two different places prior to construction of this building in 1939. Designed by Nathan C. Wyeth, headquarters, as it was known, was situated high upon a bluff surrounded by the McMillan reservoir and water plant. There was little concern that the future development around the building would interfere with radio transmissions. Throughout the city, whenever someone pulled the hook on a fire alarm box, the transmission was sent here, deciphered, then sent to all the firehouses. It was up to the fireman on watch to determine if his company was needed to respond. The system went off without a hitch except that when new technology made the vocal alarm obsolete in the mid-1970s, the tight budget prevented the fire department from acquiring an enhanced station alerting system. In 2000, the department began the transition into the new system, which like other fire departments around the world, automatically alerts fire houses to emergencies in their area and does not require a fireman to remain awake for 24 hours to listen to the dispatcher. The new system also eliminates human error. (JCG.)

Fire alarm telegraphs were found throughout all of Washington, D.C. This fire alarm pedestal with the second generation red globe light was in front of Douglas Hall, a local establishment in the Barry Farms/Hillsdale section of Anacostia in the 1920s. During that time, it was becoming a pastime for misguided teenagers to pull the fire alarm for fun. Again and again, the system was abused in all four corners of the city as many as 50 times a day. Some of the firemen in particularly troubled areas, such as Engine 25, spent their days off hiding in the bushes along side the problem fire alarms to catch the culprits. Other firemen just accepted the false alarms as part of the job. It is not unusual today to hear retired firemen recite the location and running route of every "trouble" box in their area. Once on the scene, the officer would reset the alarm box and rewind it, knowing the next call may actually be a fire. It was a particularly troubling situation. The ruby-red globes—expensive and unavailable by the 1960s—were replaced with red or orange utility lights still seen today. (LOC.)

When someone opened the door and pulled down the hook, a clockwork spring and motor would rotate a small wheel notched with the same amount of teeth as the alarm box number. Like in Morse code, the teeth would make contact with a small electrode that sent a signal to a bell or joker tape at fire alarm headquarters. From here, the same message would be sent to all the firehouses in the city. In the early days, the box number rang out over the "big gong" found in every firehouse. As of this writing, Engine 17's firehouse still has an opening on the wall between the engine room and bunkroom where this gong use to hang. It often repeated as many as four times, so that there was no mistaking where the fire was. Unfortunately, the early system was prone to being overpowered by the sounding of another box at the same time; the phenomenon was much like trying to talk over someone else's voice on a radio. On the watch desk in each company were a small joker reel and bells. The bells rang out the box number and they tape recorded it in a series of punch holes. It was not uncommon for fire chiefs to have these in their homes to keep track of goings-on in the city.

The fire alarm boxes changed little through the years except when new technology introduced more reliable electronics inside the telegraph. It was, for the most part, a failsafe system as long as it was not circumvented or abused. In this image, Mayor Walter Washington and Chief Joseph Mattare install the new telephone boxes to replace the telegraphs, cutting false alarms down by 90 percent in the first year the system was completely implemented. Some locations retained "shopkeeper" telegraph boxes, which required a responsible shop owner or police officer to turn a key to sound an alarm. Today all the telegraph and telephone boxes have been removed from the city. (JCG.)

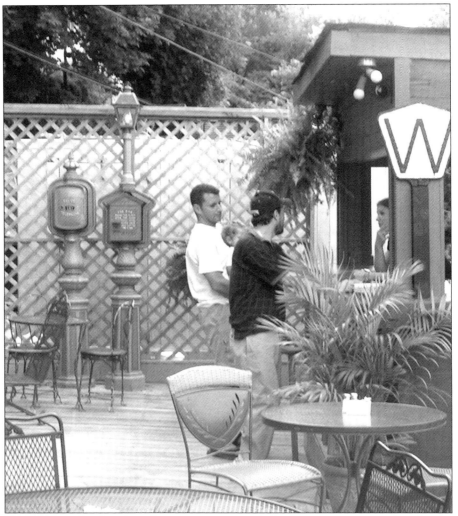

Fortunately, when the fire alarm boxes were removed, the ornate cast iron pedestals remained, probably because they weigh in excess of 300 pounds and are countersunk four feet into the ground. They are impossible to move without the help of a crane. For many years, prisoners at the Lorton Correctional Facility had the duty of operating a foundry that cast pedestals and such items for the Washington streetscape. Today the pedestals are highly sought by collectors, but thanks to the concerted efforts of Paul Williams of the D.C. Heritage Tourism Coalition, they have been listed as part of the historic streetscape and cannot be removed. The Department of Public Works has primed the remaining pedestals so the public can create works of art, memorials, or historical information. Sgt. Larry Chapman of the D.C. Firefighters Union recently set memorial plaques within pedestals located at the scene of two different fires where three D.C. firefighters were killed in 1999. When they were sold for scrap or at public auction, many pedestals became prized possessions of museums and collectors. Shown in the above photo, the D.C. fire and police pedestals were purchased from the city in the early 1990s during widening of the roads. The pedestal on the left contains a rather rare D.C. police phone box, of which only a few are known to exist today. These have been restored and are on the deck of a restaurant in Harper's Ferry, West Virginia. (CFM.)

Five

BIRD ON A WIRE

The origins of this firehouse saying were included in papers that were once part of the fire alarm repair shop. Long before the telegraph wires were buried underground, strong winds or a bird on one of the wires resulted in the firehouse gong ringing or the joker tape and desk bell tapping out a mystery alarm. A good watchstander would know this was merely a product of nature and announce throughout the firehouse, "Bird on the wire!" Today, all firehouses in D.C. have a button on the watch desk that rings an electric bell to alert the firemen to an alarm. Sometimes the button is accidentally rung and, again, the guilty person announces, "Bird on the wire!" Above, the watchman acknowledges receipt of an alarm over the vocal-alarm directly to headquarters. Next, the watchman will push the button in the extreme right lower corner of this image to call the men to the fire engine. The board on the wall kept track of which fire companies were out on other responses. (JCG.)

The quintessential rescue squadman, Harry Gates is seen here after executing another rescue during his 29-year career. A humble, quiet superhero and talented artist, he retired as the firefighting deputy in 1979. Chief Gates identified the woman in this image as "Miss V.F.W.," who was in Washington as part of a public relations campaign with the Veterans of Foreign Wars. She was staying in a loft apartment converted from an old carriage house at 1730 New Hampshire Avenue Northwest when the building caught fire around 4 a.m. At the time, Chief Gates was a fireman assigned to Rescue Squad 1, and on that particular night was assigned to ride shotgun on the squad's ambulance. But he was a fireman first, and as the ambulance left the firehouse behind the squad, he already had all of his firefighting gear on. First on the scene was Chief Elmer Stein, who entered the building to effect the rescue. He found the young woman and began to carry her out when the room exploded into fire. Wearing only his dress cap he suffered substantial burns, stumbled into a door, and was knocked unconscious. Harry Gates, who was inside as well, scooped up the girl and carried her out. The back of his coat was on fire in this image. Rescue squad captain George Deaner attempted to find another victim in the fire, but became trapped. Within moments, squad men Gates, Kefauver, and Nace returned to save their captain. All suffered burns, though none died. Chief Gates loved the fire department and still wears his Rescue Squad 1 ballcap to this day. (JCG.)

Exterior fire escapes were not as prevalent in Washington as they were in other cities, because D.C. high rises did not exceed 13 stories. Many buildings were constructed with enclosed stairwells, which protected residents from encountering smoke on the way out. However, dozens of mid-rise buildings contain open, central stairways that allow smoke and flames to travel from the basement to the top floor during a fire. Such was the case when a fire originated in the basement of the Southern Railway Building, seen at right. To escape the acrid smoke, everyone evacuated by the fire escape. Firemen were concerned that the escape would collapse and hurried the people off. (JCG.)

A similar situation to that pictured here was photographed and appeared in the union's newsletter several years ago: a mail truck stopped along its route in front of the hydrant. The mail carrier intended to stay there only a second. However, after he stumbled upon a building fire and notified the fire department, he forgot he was blocking the hydrant. Engine 3 used the same tactic pictured here, causing little damage but certainly a postal delay. In this image, the vehicle owner, distraught over having a dirty wet fire hose passed through her new car, notified the police of the situation. (JCG.)

This image shows the intersection of Fourteenth Street and V Street SE shortly before the demolition of Engine 15's firehouse in 1967. The following year, the new house was occupied and now serves as home to Engine 15, Rescue Squad 3, Battalion 3, and the Cave-In Unit. (JCG.)

Jackson Gerhart, wagon master emeritus of the D.C. Fire Department, spent his entire career at Engine 17. His love for the fire department has carried on into his retirement. Gerhart was one of the few firemen to rescue countless photographs and ephemera from the early days of the D.C. Fire Department. Jack was also a key figure in the union for many years. Most of the images in this book and every other book on the history of the D.C. Fire Department are from his collection, gathered over the course of several decades. (JCG.)

In this image, taken May 5, 1957, Johnson and Wimsatt's Lumber Yard at 901 Maine Avenue SW turns to ashes. The fourth alarm fire caused a half million dollars in damage and was cause for National Airport to close for a while because of the smoke. Sixty-five police officers were called to the scene to handle Sunday on-lookers. Fireboat *William T. Belt* supplied 16 lines during this fire. This was the second fire at this yard in 50 years; in 1907, the fireboat *Firefighter* saved the day as well. (JCG.)

Once the steam engine reached the bay of the firehouse, it rode on tracks set in the floor to assist in guiding it back. The horses were unhitched before they got into the firehouse, then were walked or brushed to cool down and put in their stalls. Once, after a hostler from Engine 23 was walking the horses to cool them down, he learned a woman from the neighborhood filed a complaint against him. She thought the fireman was talking to her when she heard him say, "You're my baby, oh yes, you are my baby!" Fire horses were treated with the same respect and comforts as would be granted close friends. (JCG.)

Chief William T. Belt's carriage was part of his funeral precession on December 16, 1908. Belt was credited with acquiring new apparatus, training, and firehouses, and with the arrival of the fireboat *Firefighter*. The next large fireboat purchased by the department was named in his honor. Chief Belt died of a sudden heart attack while working at a fire at the Tepham's Trunk Factory, located at Eckington Place and Q Street NE, which went to a third alarm. The horse is draped in a black funeral shawl; the chief's coat and helmet rest in his seat. The buggy is in original condition today in the collection of the Capitol Fire Museum and the Association of Oldest Inhabitants. (JCG.)

The young man at the far right was fresh from the tail-gunners seat of a bomber during World War II, when this picture was taken. Now retired, Deputy Fire Chief John Breen is a co-founder of the Capitol Fire Museum. From left to right are Captain Carter, Lieutenant Davis, Sergeant Hamilton, Sergeant Combs, Private Hyland, Private Hensley, Private Mocre, Private George, Private Bowsher, Private O'Hara, Private Ruggieri, Private Vilinsky, and Private Breen. The city retains control of the 1855 firehouse, which would make an ideal space for a fire museum until such time a larger space can be found. (JCG.)

Weighing 230 tons, train 173, an electric GG1, "ran away" six minutes from at Union Station on January 15, 1953. Upon arrival, she passed into the station, off the tracks, and onto the concourse, which collapsed under her immense weight. Most of the 16 coaches to her rear remained outside. Although some 40 people were hurt, no one died. On the same day, another multiple alarm incident took place at the Standard Tire and Battery Company at Tenth and H Streets NE, almost around the corner from Union Station. Many firemen were injured in an explosion during the fire, including Chief Millard Sutton. This day has gone down in the annals of D.C. Fire Department history as "Black Thursday." (JCG.)

Truck company 10 stops by Truck 1's firehouse before the firehouse was demolished for new construction on the Capitol grounds. After demolition, temporary women's dormitories were built on the site to house workers arriving in the city during World War I. Notice the open space behind the firehouse, which was the last building standing in the block for several years before it was destroyed. (JCG.)

The fire chief's buggy in 1911 was as clean then as it is today. Notice the driving gloves worn by chief's aide Owen R. Moxley. Chief Engineer Frank Wagner is seen in the passenger's seat. The soda-acid fire extinguisher had more of a visual impact than any substantial firefighting ability. This luxurious touring car, called a Carter Car, offered a ride similar to that of today's Cadillac Escalade. (JCG.)

Engine 1's Amoskeag steam fire engine is seen just outside its quarters about 1891. The engine had a pumping capacity of 700 gallons per minute. Upon arrival at the scene of a fire, the first duty of the hostler, seen on the back, was to walk the horses to a safe haven away from the fire ground. The engine would stop in front of the fire, and the hose reel, seen below, would lay a supply hose to the nearest hydrant. If no hydrant was nearby, they would lay the hose to the nearest engine with a water supply, which was often a cistern found in the street. Sometimes the steam engine would fight the fire from a distance, since it had to establish a water supply. The older model hose reel, later replaced by combination chemical hose wagons, was a 1876 McDermott Brothers model that went out of service shortly after this image was taken. With the exception of hard sleeves, the steam engine carried no hose. On the hose reel are seen the firefighter/driver, officer, and firemen. (JCG.)

The heyday of firefighting was when the *Washington Evening Star* assigned a photographer to do nothing other than chase fire trucks. The city was burning like never seen before or after. This image, dating to before 1920, shows the city's Champion water tower in action at a multiple-alarm fire in old Downtown. The water tower was a barometer on the fireground; when it was up, the firemen knew it was going to be a long night! (JCG.)

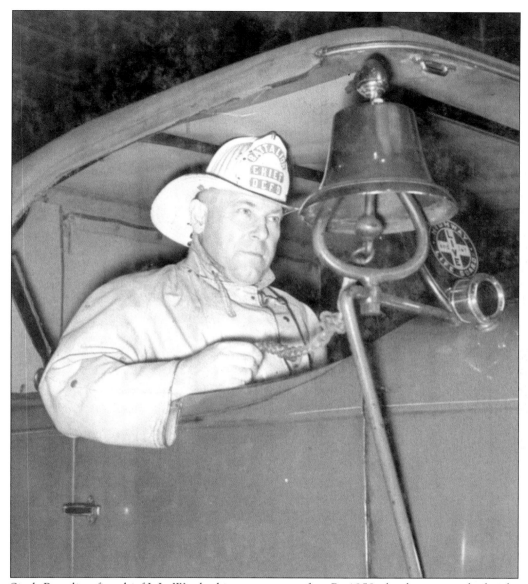

Sixth Battalion fire chief L.L. Woolard is en route to a fire. By 1958, the department had eight battalions of fire companies, and eight different fire chiefs to manage each. Battalion 1 consisted of Engines 4, 10, 12, 17, and 26, and Trucks 4, 13, and 15. Battalion 2 consisted of Engines 1, 5, 9, 23, and 29, and Trucks 2 and 5. Battalion 3 consisted of Engines 15, 25, and 32, Truck 8, and Rescue Squad 3. Battalion 5 consisted of Engines 20, 21, 28, and 31, and Trucks 9, 12, and 14. Battalion 6 consisted of Engines 2, 6, 13, and 16, Trucks 3 and 10, Rescue Squad 1, and the fireboat and foam wagons. Battalion 7 consisted of Engines 3, 7, 8, and 18, and Trucks 1 and 7. Battalion 8 consisted of Engines 19, 27, and 30, and Trucks 16 and 17. Between 1992 and 1995, management and budget cuts resulted in the closing of Battalions Chiefs 2, 7, and 8. (JCG.)

No gas, no bread, no sugar, no money, no candy, no cigarettes, no chrome, no sirens, and the tires better last! Such was the case with rationing during World War II. In this image, a recently delivered Ward LaFrance had few of the flashy items normally seen on fire engines of the era; the war prevented it. Even though the siren was found on the engine, it was not allowed to be used during war time. The apparatus is a light red, as deep red pigment was not available. (JCG.)

A two-piece engine company was standard in D.C. until the late 1980s. This enabled every engine on the scene of a fire to establish its own water supply. Today use of the hydrant or Humat valve enables a single engine to establish a water supply. An additional engine can hook up into this system and increase pressure, supply itself, or supply another engine company. Engine companies contemporary with this photo ran with five men, four on the engine and one driving the pumper, as seen in this image. The terms "wagon" and "pumper" date from the horse-drawn era when the hose wagon supplied the steam pumper. Here, Engine 3, a "Buffalo," was referred to as the wagon and the second piece the pumper, which is a Ward LaFrance. The firemen all had a designated job. The driver of the wagon established a water supply with the driver of the pumper; the officer, in the front seat, was responsible for the entire operation; and the man riding by the hose basket was the small line man, responsible for running the small booster hose seen next to him into the fire building to put out the fire. The remaining man assisted in laying the supply hose between the wagon and the pumper. (JCG.)

Only an elite group of horses was born and bred for duty in the firehouses. In this famous image, Fireman Gately takes Barney, Gene, and Tom on their final run. The steam engine was donated to the Association of Oldest Inhabitants shortly after this image was taken. Today the steamer, which had been Engine 18, is kept in storage until a suitable location for its display is obtained. The Capitol Fire Museum oversees management of the old relic and is raising funds for its conservation. Tom was the last D.C. fire horse to die, around 1936. Tom, along all other city horses, was put out to pasture in his retirement at the farms at Blue Plains Southwest. Though many of the animals were cremated after they expired, a group of firemen erected a memorial where Tom was buried commemorating the fire horses and their history. (JCG.)

Some retired fire horses were placed into service with the public works department pulling street cleaners, a demoralizing duty for them. The loyalty of the retired horses could be measured, however, when a steam fire engine came rushing past them on the way to a fire. In all the excitement, it was not unusual for the retired horse to take off down the street in pursuit, dragging the sanitation wagon behind it, the street workers trying in vain to chase him down. (JCG.)

Creating more of a liability than an asset, this half-ton bell sat inside the ambulance bay at Engine 4 for many years, orphaned since the mid-1950s when the Association of Oldest Inhabitants lost their fire museum to construction of the International Monetary Fund. The Capitol Fire Museum began an extensive search to recover and care for these items in 1999. This bell, after being removed by the Security Storage Company, was placed into storage along with Engine 18's steamer, Chief Belt's buggy, an early hose reel, the Columbia hand engine, another old bell of unknown origins, and a row of old lockers full of firemen's inscriptions from the training academy. These and many other miscellaneous items are bound for restoration and permanent exhibit when the Capitol Fire Museum comes to fruition. This one reputedly came from the Northern Liberties Fire Company. The bell is seen on page 28. (CFM.)

Engine 7, an 1898 Clapp and Jones 600-gallon-per-minute steam fire engine with a three-horse hitch, is seen here shortly after coming in service inside the R Street firehouse. The clock on the wall, linked with the fire alarm, recorded the hour the engine was dispatched to keep records in the company journal. The blanket behind the seat indicates this image was taken in winter and is for the horses, not the men! The driver's coat has been placed over the front wheel—notice this piece has a single, buttoned leather seat. On the end of the section of hard sleeve is a strainer to prevent drafting debris while suctioning from a cistern. A looped handle of a stoker's tool leans against the strainer. Notice the eagle emblazed with a "7" on the stack. This was probably hinged so that heat was retained in the boiler, and when running full steam, it fell out of the way to permit evacuation of the smoke from the firebox. The artistry on this piece is remarkable and typical of the period. (JCG.)

Many multi-story apartments of ordinary construction built between 1895 and 1921 rarely had standpipes, contained opened stairwells and pipe chases, and were "grandfathered" in from having to upgrade to modern fire codes. Many are found in Battalion 4. In this image, an engine company has commenced climbing the exterior fire escape probably to avoid the more than 50 residents trying to evacuate on the interior stairwell. In a typical operation, one fireman lowered down a rope onto which a hose line was tied and by which it was hauled up to the fire floor. This third alarm fire took place at the Nantucket Apartments, 1418 W Street NW, on a hot June day in 1965. (JCG.)

In a hostage situation during times of civil unrest in 1969, the firemen were not warned, and Truck 6's crew (using a reserve truck) hunkered down as shots were heard coming from the building at 1420 Madison Street NW. The ladder made good cover for the cops. Problems with communication between the police and fire departments are all but cured today, as the enhanced 911 center is located in a building housing both departments. Shortly after the above image was taken, police fired tear gas into the building and inadvertently set it on fire. Moments later the building was completely evacuated. (Courtesy Eugene Jackson.)

A very rare sight today, the fireboat *William Belt* passes the first of two swing bridges on the Potomac River shortly after World War II. The drawbridge is part of the Fourteenth Street bridge complex today. The last time these bridges opened is not recorded, but with construction of new "fixed" bridges across the river, as well as the Metro bridge, few ships of any size can navigate the waters up to Georgetown today. The structure with dual smoke stacks above the railroad bridge was a steam plant that operated the massive geared "swing" mechanism, still in place today. Retired firemen relate how surprising it was to arrive down at the fireboat and for the reminder of the shift, do nothing else but shovel coal into the *Belt*'s big boiler. (Lindsey Cohee.)

This was Truck 5's firehouse until the company moved in with Engine 29. Engine 5 is seen peering out of the bay at right. This old relic of bygone days was retired after serving through the riots as Truck 4. The Capitol Fire Museum owns this truck today, having purchased it from a scrap yard in central Virginia after D.C. firefighter Jimmy Woodhouse stumbled upon it. For the most part, the truck is in fair shape, and will be used as a static exhibit interpreting the riots and the impact they had on the city and the fire department. The wooden crew cover came into style about the time of the Watts Riots. Apparatus that did not have such crew cabs during the riots of 1968 had to settle for a chicken-wire cover, which helped repel bottles, rocks, and whatever else was thrown at the firemen. The pumper from Engine 30 was once in the above mentioned scrap yard, and it still had the wire-mesh attached to it. (JCG.)

Probably the strongest aerial ladder the city ever owned, Truck 9's LTI, seen here in 1994 in front of Engine 1's firehouse, had a working tip load of 1,000 pounds when delivered in 1981. It should have set the standard for future ladders, but this and one other remained the only examples. Regardless of the angle or height at which it was extended, it never faltered, even in the worst conditions. It remains in service today, rehabilitated and ready to serve another 20 years. (Donald Barrett.)

Engine Company 16's 1924 Seagrave had a pumping capacity of 1,000 gallons per minute. Seagrave began the tedious task of applying the image of George Washington on every piece of apparatus they delivered to the city. More than likely it was part of the nation's preparation for the bicentennial of George Washington's birthday, only a few years away. The small line basket became standard on all D.C. engines until after World War II, when apparatus manufacturers began coiling the hose around a reel.

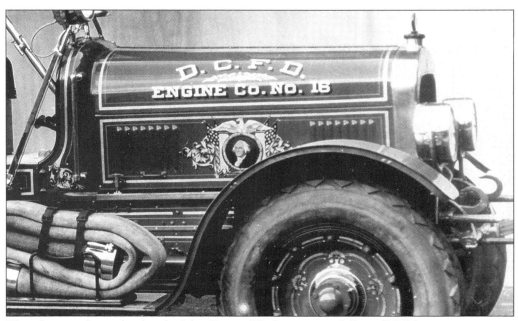

This close-up shows the detail of the George Washington medallion. (JCG.)

Sitting on the hydrant at the Martin Wiegard's Planing Mill fire on May 17, 1909, Engine 16's steamer is the delight of all boys big and small. In this image, it appears the steam relief valve is open and a full "head" is evidence by the billowing smoke from the boiler. The steam engine's oiler is barely discernable by the rear wheel. Notice the coal dumped in the street behind the steamer; the delivery of coal indicates that this was a large fire. (JCG.)

Engine 17's men pause for a photo in front of the firehouse with their mascot c. 1906. Nearly every firehouse had a mascot, though few were Dalmatians. Dogs like the one seen at left were probably strays taken in by the men. While there were few written rules about having mascots at this time, after World War II mascots were frowned upon and today are not allowed. There are many old stories about firehouse dogs in D.C.; one of them was about a pup adopted by the men of Engine 27. The dog thrilled the local children, who regularly fed him candy. He passed away shortly thereafter. Dalmatians and other territorial dogs kept good watch of the firehouse when the firemen were out. They also kept the horses at bay and protected them from danger. Notice the harnesses dangling in the background. They were set into a system that, when activated, automatically secured the horses to the front of the engine. (JCG.)

The screech made by friction from a fireman's hands against a fire pole is a sound as old as the firehouses themselves. During the 1930s, a move was made to begin building only single-floor firehouses to rid the department of many injuries incurred by tired firemen using the pole. By the 1960s, space was limited in the construction of many firehouses, which resulted in the second story again being added to new firehouses. Ironically, some of the more modern firehouses in the city have the highest poles known to exist. In this 1974 image, a firefighter is sliding down the pole from the bunk room to the apparatus floor at the quarters of Truck 5. During this era, many of the poles were encased in "closets" in the bunk room to keep noxious fumes from entering where the firefighters would sleep. (JCG.)

Since the 1960s, fires have occurred daily in hundreds of derelict and abandoned row houses throughout much of Northwest and Northeast D.C. Once posh neighborhoods, they turned into slums after the riots. Today the same building in the same location is valued at a half million dollars. The fire department has always prided itself on its aggressive interior firefighting. Standard operating procedures in the city, coupled with the quality of construction in these old homes, allow for safe initial interior attacks on the fire if it is not too advanced. Unfortunately, because of the lightweight and meager quality of construction in new homes throughout the city today, the standards may have to be reevaluated. (Thomas Barnard.)

Engine Company 4 was the first all African-American fire company in Washington, seen here c. 1910. The steam engine is a 1907 American LaFrance rated at 700 gallons per minute, and the hose wagon, also an American LaFrance, was built in 1908. It was not uncommon for this company to have far more men than other companies, as seen with the 14 firemen in this picture. However, as there was no other all African-American fire companies at the time, all extra personnel had to stay at this firehouse, though it was to the benefit of the men and the neighborhood. (JCG.)

The riots changed the city forever. Truck 4 fought fires for the duration of the riots, which lasted from April 5, 1968, for almost a week. The number of fires has not been totaled, but the property damage is known to have been in the millions. Twelve people died, though many more than that were rescued. Truck 4 later was retired to Truck 5. Many vacant lots exist along the Fourteenth Street corridor today, reminders of the mass destruction that took place. (JCG.)

These Ford Emergency 1 "squad wagons" served the city through a myriad of fires and technical rescues, and were assigned to all four companies at one time or another. Seen here in the early 1990s is Rescue Squad 4 shortly before being decommissioned in 1993. (JE.)

Truck Company 12 is pictured here in front of the quarters with an early wooden aerial, c. 1940. The large I-beam above the truck bay survives from the horse-drawn era. It was used to hoist hay up into the loft on the second floor. (JCG.)

Sitting at the watch desk with an unidentified visitor, firemen from Engine Company 19, also know as the fireboat *Firefighter*, allow time for a photo *c.* 1906. The man might be Morgue master Shoenburger, whose office was downstairs. This firehouse was electrified at an early age, in part due to its being associated with the morgue office and to the need to keep ice for the deceased. A joker tape, bells, and an early candlestick telephone were once modern technology. (JCG.)

Several years ago, the author was approached by the History Channel for information about the hoof of a Washington D.C. fire horse found in storage of the Smithsonian Institution. It seems a house fire at the foot of Capitol Hill *c.* 1890 required the response of Engine 3. Racing as fast as possible, the driver of Engine 3 crossed the railroad tracks on the Mall and one of the horses snagged its hoof between the rail and the road bed instantly amputating it. It remained there until recovered by police. At the scene of the fire, the hostler had no idea what had occurred, and the horses were tied to a nearby post for the duration of the fire as was the practice. After the fire, it was noticed one of the horses wounded, near death. The department veterinarian was called but nothing could be done and the horse was euthanized. (JCG.)

A ghostly image of Engine 20's quarters was all that could be processed from an early glass negative. This image was not known to exist until recently. More research is necessary before it can be determined what era steam engine is proudly brought to attention with the firemen. With the close of this book, we bid a fond farewell to this vigilant old firehouse, demolished only four years ago. (JCG.)